陳式太極拳 競賽套路(56式)

Chen style taijiquan competition routine (56 form)

《國際武術大講堂系列教學》 編委會名單

名譽主任:冷述仁

名譽副主任: 桂貴英

主 任:蕭苑生

副 主 任:趙海鑫 張梅瑛

主編:冷先鋒

副 主 編:鄧敏佳 鄧建東 陳裕平 冷修寧

冷雪峰 冷清鋒 冷曉峰 冷 奔

編 委:劉玲莉 張貴珍 李美瑤 張念斯

葉旺萍 葉 英 陳興緒 黃慧娟(印尼)

葉逸飛 陳雄飛 黃鈺雯 王小瓊(德國)

葉錫文 翁摩西 梁多梅 ALEX (加拿大)

冷 余 鄧金超 冷飛鴻 PHILIP (英國)

顧 問: 陳世通 馬春喜 陳炳麟

法律顧問: 王白儂 朱善略 劉志輝

《陳式太極拳競賽套路 56 式》編委會名單

主 編: 冷先鋒 鄧敏佳

副主編:劉玲莉 李美瑤

編 委: 張念斯 葉旺萍 周煥珍 陳興緒 葉 英

莫麗芬 杜知江 黃綠英 鄭安娜 何玉清

趙鳳儀 莊那宏 陳雄飛 黃鈺雯 歐陽美光

鄧建東 陳裕平 冷飛鴻 余 瓊 王小瓊(德國)

梁多梅 張貴珍 冷飛彤 王子娟 艾力(加拿大)

金子樺 楊海英 吳志強 崔順儀 王振名(臺灣)

黃碧玉 何淑貞 占賽珍 戴裕強 吳鵬儀 (加拿大)

黃春燕 李國光 林敬朗 唐祥貴 甘鳳群

翻 譯: Philip Reeves (英國) Alex Nasr(加拿大) 金子樺 (香港) XiaoQiong Wang(德國)

Yeung Wing Yee(美國)

序言

武術,源于中國、屬于世界。

欣聞學生冷先鋒近期出版發行《陳式太極拳競賽套路 56 式》一書,對此表示由衷的祝賀。其實,早在九十年代初,冷先鋒就追隨我學習各式太極拳競賽套路及傳統套路,學習態度一絲不苟、認真做好每一招的細節動作,近30年一直從事武術太極拳的教學,我特別欣賞他做事兢兢業業、持之以恆,非常專心地去做武術太極拳事業,而且為人特別低調、謙虛謹慎,就算到後來他被香港特區政府以《優秀人才入境計劃》引進到香港,都會不間斷的利用網絡請教我各種技術上和教學上的種種困難和經驗,本人親眼目睹和見證了他的一步步腳印和踏踏實實的成長。

在眾多學生當中,冷先鋒算是比較年長的,卻經常會以小師弟的身份請 教比他年紀小的師弟師妹們,對陈式太極拳的各種套路尤為專注,加上多 年來一邊教學一邊不斷學習積累,成就了這本《陳式太極拳競賽套路 56 式》 的著作,他系統地從陰陽虛實、身法轉換,眼神和方位等全面地闡述了每 一個招式,語言通俗易懂、圖文並茂,就算是業餘愛好者和初學者也能當 入門的教程,重要的是還配有英文翻譯,更是外國朋友學習太極拳的福音。

中華武術的傳承發展與創新,離不開國家武術主管部門及廣大武術工作者的不懈努力。民族的才是世界的,希望本書的出版,能為武術早日進入奧運,增進各國武術交流,為太極拳的普及與提高盡一份綿薄之力。

是以為序。

世界太極拳冠軍 王二平 2020年5月

Preface

Wushu origins from China - Belongs to the world

I am glad to hear that my student, Mr. Leng Xianfeng will publish the book "Chen style taijiquan competition routine 56 form", and sincerely congratulate him. In fact, Mr. Leng Xianfeng followed me to learn various Tai Chi competition routines and traditional routines in the early 1990s. He was meticulous in his study and carefully worked out the details of each movement. He has been engaged in teaching of martial arts and Tai Chi for nearly 30 years. I particularly appreciate his conscientious hard working and perseverance. He is not only very attentive to the martial arts and Tai Chi career, but also very restrained, modest, and cautious. Even though he had been later introduced to Hong Kong by the Hong Kong SAR Government as " Excellent Talent Project ", he has been consulting me via the Internet about various technical and teaching difficulties and experiences. I have witnessed and experienced how he has steadily grown step by step.

He is relatively older among the many of my students, but he used to consult with his younger brothers and sisters as a younger brother. He has been particularly attentive to the various kinds of Chen style Taijiquan and kept learning while teaching for years. His accumulated knowledge and experience enable the completion this book "Chen style taijiquan competition routine 56 form". It systematically elaborates every movement in aspects of transformations of Yin-Yang, emptiness-solidity, body-shifting, eye-looking and positions, etc. There are full of Illustrations in the book. The descriptions in it are easy to understand. It is suitable for both amateurs and beginners as basic tutorial. The important is that it is also translated into English which is the gospel of foreign friends learning Tai Chi.

The inheritance, development and innovation of Chinese martial arts are inseparable from the unremitting offorts of the authorities of national Wushu as well as many Wushu' co-workers. Not only It belongs to our Nation but also to the world. I hope that the publication of this book will make some contributions to accelerate the Wushu entering the Olympic Games, enhance the exchange of Wushu in various countries, and contribute to the popularization and improvement of Tai Chi.

World Taijiquan Champion
Erping Wang
May 2020

冷先鋒簡介

江西修水人,香港世界武術大賽發起人,當代太極拳名家、全國武術太極拳冠軍、香港全港公開太極拳錦標賽冠軍、香港優秀人才,現代體育經紀人,自幼習武,師從太極拳發源地中國河南省陳家溝第十代正宗傳人、國家非物質文化遺產傳承人、國際太極拳大師陳世通大師,以及中國國家武術隊總教練、太極王子、世界太極拳冠軍王二平大師。

中國武術段位六段、國家武術套路、散打裁判員、高級教練員,國家武術段位指導員、考評員,擅長陳式、楊式、吳式、武式、孫式太極拳和太極劍、太極推手等。在參加國際、國內大型的武術比賽中獲得金牌三十多枚,其學生弟子也在各項比賽中獲得金牌四百多枚,弟子遍及世界各地。

二零零八年被香港特區政府作為"香港優秀人才"引進香港,事蹟已編入《中國太極名人詞典》、《精武百傑》、《深圳名人錄》、《香港優秀人才》;《深圳特區報》、《東方日報》、《都市日報》、《頭條日報》、《文彙報》、《香港01》、《星島日報》、《印尼千島日報》、《國際日報》、《SOUTH METRO》、《明報週刊》、《星洲日報》、《馬來西亞大馬日報》等多次報導;《中央電視臺》、《深圳電視臺》、《廣東電視臺》、《香港無線 TVB 翡翠臺》、《日本電視臺》、《香港電臺》、《香港商臺》、《香港新城財經臺》多家媒體電視爭相報導,並被美國、英國、新加坡、馬來西亞、澳大利亞、日本、印尼等國際幾十家團體機構聘為榮譽顧問、總教練。

冷先鋒老師出版發行了一系列傳統和競賽套路中英文 DVD 教學片,最新《八 法五步》、《陳式太極拳》、《長拳》、《五步拳》、《陳式太極劍》、《陳式太 極扇》、《太極刀》等太極拳中英文教材書,長期從事專業的武術太極拳教學,旨在推廣中國傳統武術文化,讓武術太極拳在全世界發揚光大。

冷先鋒老師本著"天下武林一家親"的理念,以弘揚中華優秀文化為宗旨,讓中國太極拳成為世界體育運動為願景,以向世界傳播中國傳統文化為使命,搭建一個集文化、健康與愛為一體的世界武術合作共贏平臺,以平臺模式運營,走產融結合模式,創太極文化產業標杆為使命,讓世界各國武術組織共同積極參與,達到在傳承中創新、在創新中共享、在共用中發揚。為此,冷先鋒老師於2018年發起舉辦香港世界武術大賽,至今已成功舉辦兩屆,盛況空前。

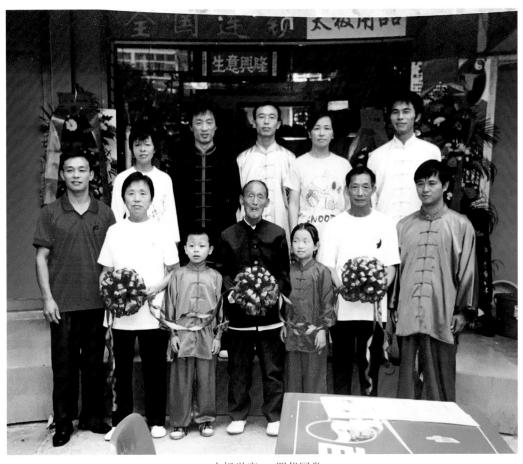

太極世家 四代同堂

Profile of Master Leng Xianfeng

Originally from Xiushui, Jiangxi province, Master Leng is the promoter of the Hong Kong World Martial Arts Competition, a renowned contemporary master of taijiquan, National Martial Arts Taijiquan Champion, Hong Kong Open Taijiquan Champion, and person of outstanding talent in Hong Kong. A modern sports agent, Master Leng has been a student of martial arts since childhood, he is a 11th generation direct descendant in the lineage of Chenjiagou, Henan province – the home of taijiquan, and inheritor and transmitter of Intangible National Cultural Heritage. Master Leng is a student of International Taiji Master Chen Shitong and Taiji Prince, Master Wang Erping, head coach of the Chinese National Martial Arts Team and World Taiji Champion.

Master Leng, level six in the Chinese Wushu Duanwei System, is a referee, senior coach and examiner at national level. Master Leng is accomplished in Chen, Yang, Wu, Wu Hao and Sun styles of taijiquan and taiji sword and push-hands techniques. Master Leng has participated in a series of international and prominent domestic taijiquan competitions in taiji sword. Master Leng has won more than 30 championships and gold medals, and his students have won more than 400 gold medals and other awards in various team and individual competitions. Master Leng has followers throughout the world.

In 2008, Master Leng was acknowledged as a person of outstanding talent in Hong Kong. His deeds have been recorded in a variety of magazines and social media. Master Leng has been retained as

an honorary consultant and head coach by dozens of international organizations in the United States, Britain, Singapore, Malaysia, Australia, Japan, Indonesia and other countries.

Master Leng has published a series of tutorials for traditional competition routines on DVD and in books, the latest including "Eight methods and five steps", "Chen-style taijiquan", "Changquan", "Five-step Fist" and "Chen-style taiji sword", "Chen-style taiji fan", "Taijidao". Master Leng has long been engaged as a professional teacher of taijiquan, with the aim of promoting traditional Chinese martial arts to enable taijiquan to spread throughout the world.

Master Leng teaches in the spirit of "a world martial arts family", with the goal of "spreading Chinese traditional culture, and achieving a world-wide family of taijiquan." He promotes China's outstanding culture with the vision of "making taijiquan a popular sport throughout the world". As such, Master Leng has set out to build an international business platform that promotes culture, health and love across the world of martial arts practitioners to achieve mutual cooperation and integrated production and so set a benchmark for the taiji culture industry. Let martial arts organizations throughout the world participate actively, achieve innovation in heritage, share in innovation, and promote in sharing! To this end, Master Leng initiated the Hong Kong World Martial Arts Competition in 2018 and has so far successfully held two events, with unprecedented grandeur!

冷先鋒太極(武術)館

地址:深圳市羅湖區紅嶺中路1048號東方商業廣場一樓、三樓

電話:13143449091 13352912626

【名家薈萃】

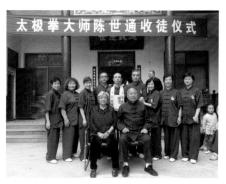

陳世通收徒儀式

王二平老師

趙海鑫、張梅瑛老師

武打明星梁小龍老師

王西安老師

陳正雷老師

余功保老師

林秋萍老師

門惠豐老師

張山老師

高佳敏老師

蘇韌峰老師

李德印教授

錢源澤老師

張志俊老師

曾乃梁老師

郭良老師

陳照森老師

張龍老師

陳軍團老師

220189

【名家薈萃】

劉敬儒老師

白文祥老師

張大勇老師

陳小旺老師

李俊峰老師

戈春艷老師

李德印教授

馬春喜、劉善民老師

丁杰老師

付清泉老師

馬虹老師

李文欽老師

朱天才老師

李傑主席

陳道雲老師

馮秀芳老師

陳思坦老師

趙長軍老師

【獲獎榮譽】

【電視采訪】

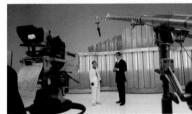

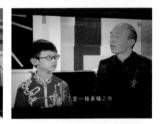

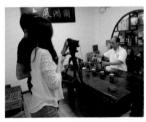

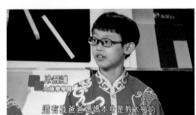

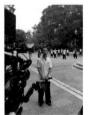

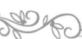

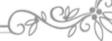

【電視采訪】

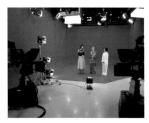

【電臺訪問】

【合作加盟】

【媒體報道】

【培訓瞬間】

百城千萬人太極拳展演活動

雅加達培訓

汕頭培訓

王二平深圳培訓

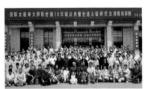

師父70大壽

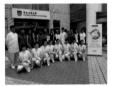

香港公開大學培訓

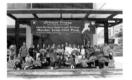

印度尼西亞培訓

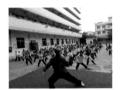

松崗培訓

香港荃灣培訓

王二平深圳培訓

陳軍團香港講學

印尼泗水培訓

油天培訓

印尼扇培訓

七星灣培訓

陳軍團香港講學培訓

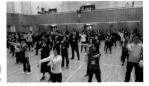

油天培訓

美國學生

馬春喜香港培訓班

【賽事舉辦】

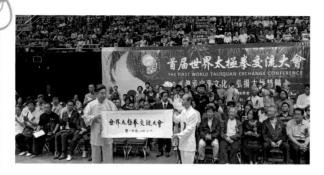

首届世界太極拳交流大會

第二届"太極羊杯"香港世界武術大賽

第二届"太極羊杯"大賽

日本德島國際太極拳交流大會

首届世界太極拳交流大會

馬來西亞武術大賽

東莞擂臺表演賽

首届永城市太極拳邀請賽

首届永城市太極拳邀請賽

2018首届香港太極錦標賽

2019首届永城市太極拳邀請賽

【專賣店】

目 錄

DIRECTORY

第一段 First section		
1. 第一式 起勢 Opening form		(26)
2. 第二式 右金剛搗碓		(27)
3. 第三式 攬紮衣 Fasten coat		(33)
4. 第四式 右六封四閉		(37)
5. 第五式 左單鞭 Single Whip (Left Side)		(41)
6. 第六式 搬攔捶 Block, Parry, Punch	110	(44)
7. 第七式 護心捶 Protect heart with fists		(48)
8 . 第八式 白鶴亮翅White Crane Flashes its Wings		(50)
9. 第九式 斜行拗步 Oblique Stance with Twist Step		(53)
10. 第十式 提收 Lift and retract		
11. 第十一式 前趟		(58)
第二段 Second section		
		164
12. 第十二式 右掩手胘捶 Hide Hand and Strike with Fist (Right Side)		(61)

13. 第十三式 披身捶 Fists roll over body	(64)
14. 第十四式 背折靠 Back-twist butt	(66)
15. 第十五式 青龍出水	(68)
16. 第十六式 斬手	(70)
17. 第十七式 翻花舞袖	(72)
18. 第十八式 海底翻花	
19. 左掩手肱捶 Hide Hand and Strike with Fist (Left Side)	(75)
20. 左六封四閉	(78)
21. 右單鞭	(82)
第三段 Third section	
22. 右雲手	(85)
23. 左雲手	(89)
24. 高探馬	
25. 右連珠炮	(95)
26. 左連珠炮	(99)
27. 閃通背(Flash through Back	104)

第四段 Fourth section

28.指襠捶	(106)
Strike Groin with Fist	
29. 白猿獻果	(109)
White Ape Offering Fruit	
30. 雙推手	(111)
Double Push Hands	
31. 中盤	(112)
Middle Winding	
32.前招	(115)
Forward trick	
33. 后招	(117)
Backward trick	
34. 右野馬分鬃	(118)
Part Wild Horse's Mane (Right Side)	
35. 左野馬分鬃	(120)
Part Wild Horse's Mane (Left Side)	
36. 擺蓮跌叉	(122)
Fallen lotus (Swing kick drop split)	
37. 左右金鷄獨立	(128)
Golden Rooster Stands on one Leg (Left a	
第五段 Fifth section	
38. 倒卷肱	(132)
Turn over arms (repulse monkey)	
39. 退步壓肘	(136)
Step back and press from elbow	
40. 擦腳	(139)
Slap foot	
41.蹬一跟	(141)
Heel kick	
	(144)
Turn out flowers from seabed	
43. 擊地捶	(145)
Punch to ground	(143)
runch to ground	

44. 翻身二起腳	(147)
Turn over and double kick	
45. 雙震腳	(151)
Thud with both feet	
第六段 Sixth section	
46. 蹬腳	(153)
Heel Kick	
47. 玉女穿梭	(154)
Jade Maiden Working Shuttles	
48. 順鸞肘	(155)
Smooth Elbow Strike	
49. 裹鞭炮	(157)
Wrapping Firecrackers	
50. 雀地龍	(160)
Dragon Dives to Ground	
51. 上步七星	(162)
Step Forward Seven Stars	
52. 退步跨虎	(164)
Step back straddle tiger	
53. 轉身擺蓮	(166)
Turn Body, Swing (Lotus) Kick	
54. 當頭炮	(168)
Head-on cannons	
55. 左金剛搗碓	(169)
Guardian Pounds Mortar (Left Side)	. 181
56. 收勢	(172)
Closing form	
1.70	
注釋:	
表示前腳掌着地。	
表示腳跟着地。	

表示其中一只腳懸空的動作。

(一) 起勢 1.Opening form

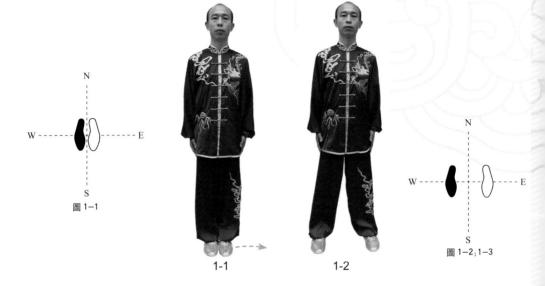

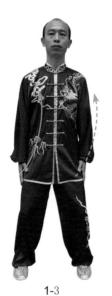

- **1 並腳直立** 身體自然直立,兩手鬆垂輕貼大腿外側, 目視正前方(以正前方是正南面)(圖 1-1);
 - a. Stand upright feet together body naturally upright, arms relaxed with palms resting lightly on outside of thighs, look straight ahead (straight ahead is "south" on the compass);
- **2** 開步肩寬 左腳向左横開一步,與肩同寬,屈膝松胯, 目視前方(圖1-2:1-3)。
 - b. Step shoulder width apart move left foot one step to the left, shoulder width apart, bend knees and relax hips look ahead.

2. Guardian Pounds Mortar (Right Side)

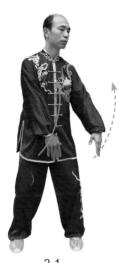

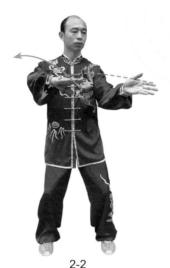

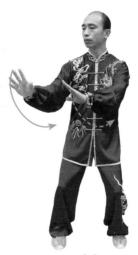

2-1

2-3

a. Left turn lift arms, turn body left, weight slightly right, lift arms out to the left, point of force on the forearm, palms inwards, look ahead to the left;

2 右轉平捋 身體右轉,重心微偏左,兩掌向右平捋, 掌心向外, 目視兩掌方向(圖 2-2,2-3);

b. Right turn pull level - turn body right, weight slightly left, palms pull level to the right, palms outwards, look in direction of the palms.

2. Guardian Pounds Mortar (Right Side)

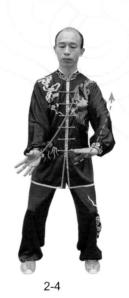

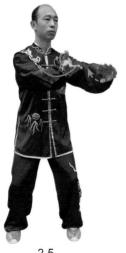

- 3 左轉外掤 身體左轉,重心微偏右,兩臂螺旋向左 上方掤出,高與肩平,掌心向外,力達掌根,目視 兩掌方向(圖 2-4;2-5);
 - c. Left turn lift outwards turn body left, weight slightly right, arms spiral and lift out to the upper left, to shoulder level, palms facing outwards, force expressed through base of palms, look in direction of the palms;

2. Guardian Pounds Mortar (Right Side)

2-8

2-6

- 4 右轉平捋 身體右轉, 重心左移, 兩臂螺 旋向右平捋,掌心向外,同時右腳尖外擺. 目視兩掌方向(圖 2-6,2-7):
 - d. Right turn pull level turn body right, shift weight left, arms spiral and pull level to the right, palms facing outwards, at the same time swing right toe outwards, look in direction of the palms;
- 身體左轉, 重心右移, 目視兩 5 重心右移 掌方向(圖2-8):
 - e. Shift weight right turn body left, shift weight right, look in direction of the palms;

2. Guardian Pounds Mortar (Right Side)

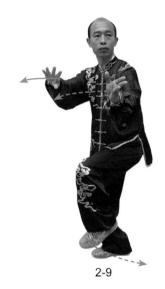

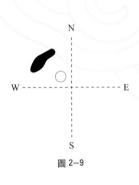

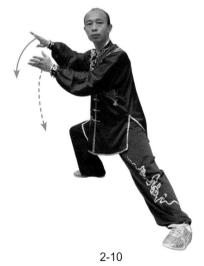

- 6 擦腳平推 提左腳向左前方擦出,同時兩掌 向右后方平推,力達掌根,目視左腳方向; (圖 2-9,2-10);
 - f. Slide foot push level lift left foot and slide out to the front and left, at the same time push palms level to the right and rear, look in direction of left foot;

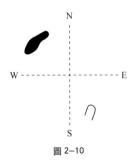

2.Guardian Pounds Mortar (Right Side)

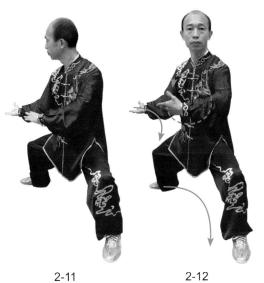

g. Swing palms relax hips – turn body left, shift weight left, relax hips swing palms, dip pelvis in a downward arc, look in direction of the palms;

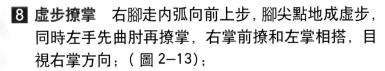

h. Empty stance flick palm – step right foot forward in an inward arc, rest on tips of toes and adopt empty stance, at the same time with left elbow bent flick left palm, flick right palm forward and bring left palm to meet it, look in direction of right palm;

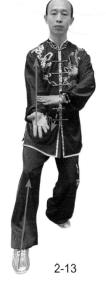

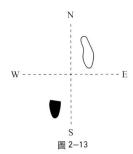

2. Guardian Pounds Mortar (Right Side)

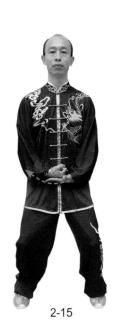

- 9 舉拳提膝 右掌變拳微下沉再上舉,與鼻同高,左掌收至腹前,掌心向上,同時提右膝,高過水平,腳尖下垂,目視前方(圖 2-14);
 - i. Raise fist lift knee right palm becomes fist, dip slightly before raising to nose level, draw left palm in front of belly, palm facing upwards, at the same time lift right knee, higher than level, toes hanging down, look ahead;

j. Thud foot pound fist – drop right foot with a thud, shoulder width apart, weight slightly left, feet parallel, at the same time pound back of right fist onto left palm, look ahead.

3. Fasten coat

3-1

- 1 左轉托拳 身體微右轉再左轉,重心先右移再左移,向左向上托拳,目視托拳方向(圖 3-1;3-2);
 - a. Turn left fist-on-palm turn body slightly right then left, shift weight first right then left, lift fist-on-palm left and upwards, look in direction of fist-on-palm;

3. Fasten coat

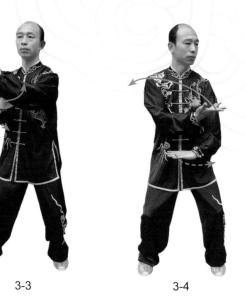

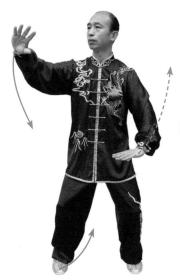

- **2** 變掌分開 身體右轉,重心右移,右拳變掌,劃 弧分開,目視右掌方向(圖 3-3,3-4,3-5),
 - b. Make palm and separate turn body right, shift weight right, right fist becomes palm, draw an arc and separate, look in direction of right palm;

3. Fasten coat

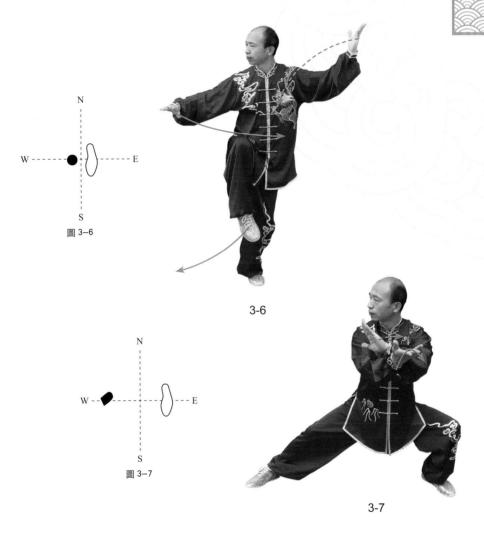

- **③ 擦腳合臂** 身體右轉,重心左移,提右腳向右擦腳,同時兩臂劃弧相合,右臂在外,目視右腳方向(圖 3-6,3-7),
 - c. Slide foot close arms turn body right, shift weight left, lift right foot and slide to the right, at the same time arms draw an arc and come together, right arm on the outside, look ahead to the right foot;

3. Fasten coat

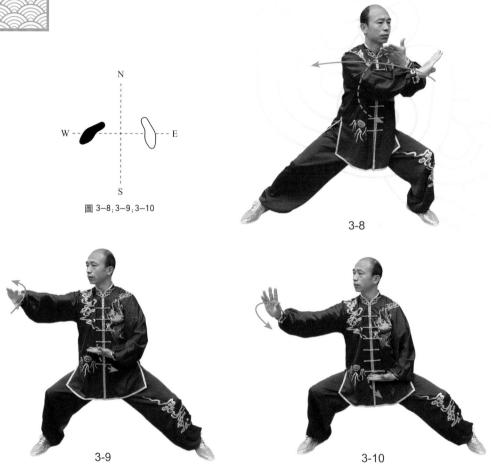

- 4 横拉立掌 身體微左轉再右轉,重心右移,右掌内旋向右横拉,立掌,力達掌根,同時左掌外旋收至腹前,掌心向上,成右偏馬步,目視右掌方向(圖 3-8,3-9,3-10)。
 - d. Draw across palm upright turn body slightly left then right, shift weight right, rotate right palm inwards and draw across to the right, turn palm upright, force expressed through base of palm, at the same time rotate left palm outwards and draw in front of belly, shift weight right, adopt a right-biased horse stance, look in direction of right palm.

4. Six Sealing and Four Closing (Right Side)

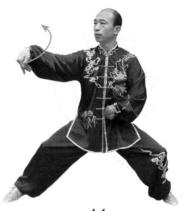

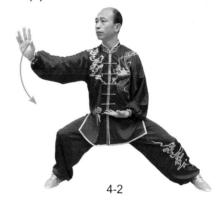

- 1 轉體旋腕 身體左轉再右轉,重心左移 再右移,同時兩手腕外旋,目視右掌方 向(圖 4-1;4-2;4-3);
 - a. Turn body rotate wrists turn body left then right, shift weight left then right, at the same time rotate wrists outwards, look in direction of right palm;

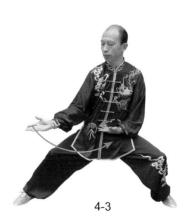

4. Six Sealing and Four Closing (Right Side)

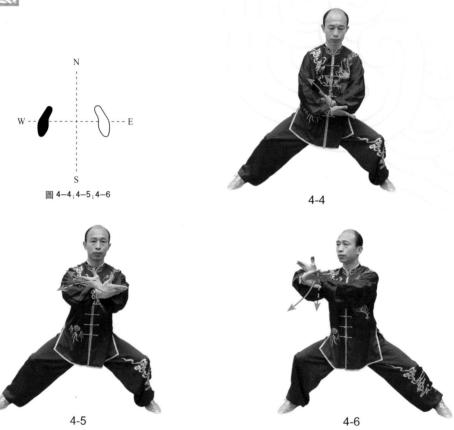

2 下捋掤擠 身體左轉再右轉,重心左移再右轉,右手向左下捋,同時左掌外旋與右臂相搭,掌心向内,重心右移,兩臂向前向右掤出,右臂内旋,掌心向外,有擠之意,目視兩臂方向;(圖 4-4,4-5,4-6);

b. Pull down lift push – turn body left then right, shift weight left then right, pull right hand down to the left, at the same time rotate left hand outwards and bring right hand to meet it, palm facing inwards, shift weight right, lift arms outwards to the front and right, rotate right arm inwards, palm facing outwards, as if in a crowd, look in direction of the arms:

4. Six Sealing and Four Closing (Right Side)

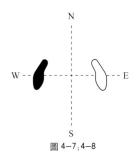

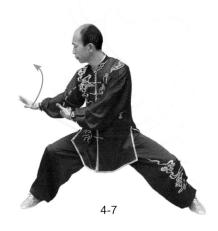

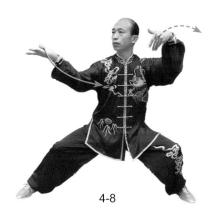

- 3 左刁右托 身體先右轉再左轉,重心左 移,同時兩臂向右劃弧下采,向左、向 上刁托,左掌變刁手于左耳側,右手劃 弧托掌于右肩前,目視右掌方向;(圖 4-7;4-8);
 - c. Left grip right lift turn body first right then left, shift weight left, at the same time draw arms in an arc and pull down, grip and lift left and upwards, left hand grip beside left ear, right hand lift to front of right shoulder, look in direction of right palm;

4. Six Sealing and Four Closing (Right Side)

- 4 左轉旋掌 身體左轉,兩臂螺旋相合于左耳 側,目視左掌方向(圖 4-9);
 - d. Left turn rotate palm turn body left, arms spiral and come together beside left ear, look in direction of left palm;

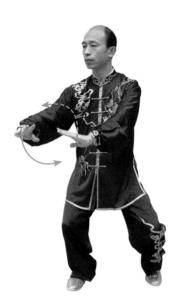

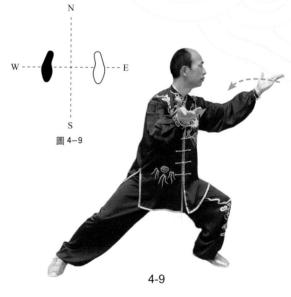

- 4-10
- W ---- E

 S

 M 4–10
- 5 虚步按掌 身體右轉,重心右移,兩掌向右、 向下按掌,同時左腳收至右腳内側,成虚步, 目視兩掌方向(圖 4-10)。
 - e. Empty stance press palms turn body right, shift weight right, palms to right, press palms down, at the same time bring left foot to inside of right foot, look in direction of the palms.

(五)左單鞭

5. Single Whip (Left Side)

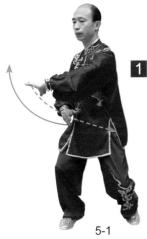

- **1 右轉推收** 身體右轉,左掌向前下方推壓,右手回收 和左手形成對拉,目視左掌方向;(圖 5-1);
 - a. Right turn push pull turn body right, push left hand forwards and downwards and pull right hand back, the two hands an opposing pair, look in direction of left hand;

- **2** 左轉提勾 身體左轉,右掌變勾手,向右前方頂出,以腕部爲力點,同時左掌收至腹前,掌心向上,目視右勾手方向(圖 5-2;5-3);
 - b. Left turn rising hook turn body left, right palm becomes hook, push upwards and outwards to front and right, point of force in the wrist, at the same time draw left hand in front of belly, palm facing upwards, look in direction of right hook;

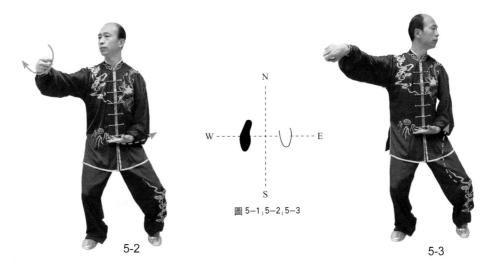

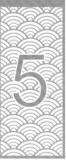

(五)左單鞭

5. Single Whip (Left Side)

- **3 屈膝擦腳** 右腳屈膝,提左 腳向左擦出,目視左腳方向 (圖 5-4,5-5);
 - c. Bend knee slide foot bend right knee, lift left foot and slide out to the left, look in direction of left foot;

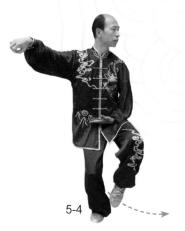

- 4 重心左移 身體左轉,重心左移,襠走下弧, 目視前方(圖 5-6);
 - d. Shift weight left turn body left, shift weight left, dip pelvis in a downward arc, look ahead;

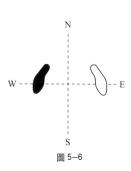

(五)左單鞭

5. Single Whip (Left Side)

- **5** 右移穿掌 身體右轉,重心右移,左 掌向右勾手方向穿出,目視左掌方向 (圖 5-7);
 - e. Shift right cross palms turn body right, shift weight right, left palm crosses over right hook, look in direction of left hand;

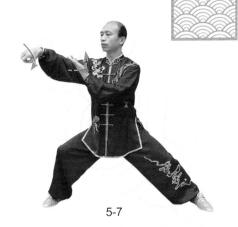

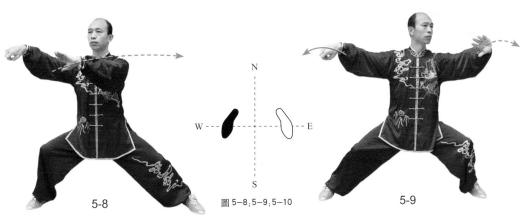

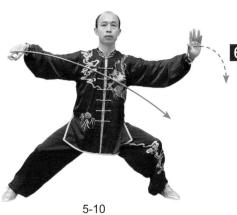

- 6 横拉立掌 身體左轉,重心左移,同時 左掌内旋,向左横拉,立掌,成左偏馬步, 目視前方(圖 5-8,5-9,5-10)。
 - f. Draw across palm upright turn body left, shift weight left, at the same time rotate left palm inwards, draw across to the left, turn palm upright, adopt a left-biased horse stance, look ahead.

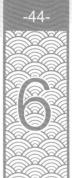

(六)搬攔捶

6. Block, Parry, Punch

- 11 劃弧變拳 身體左轉,重心先左移再右移,同時兩掌變拳,逆時針劃弧,先向左再向右,收至右胯旁,拳眼向后,目視右拳方向(圖6-1,6-2,6-3),
 - a. Draw arc make fists turn body left, shift weight first left then right, at the same time palms become fists, arcing counterclockwise, first left then right, draw to right of waist, fist-eye backwards, look in direction of right fist;

-45-

(六)搬攔捶

6. Block, Parry, Punch

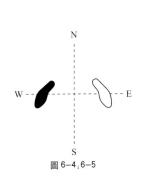

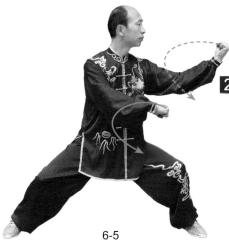

- 2 左轉橫擊 身體左轉,重心左移,兩拳 向左后方横擊,拳眼向后,目視左拳方 向(圖6-4:6-5):
 - b. Left turn strike across turn body left, shift weight left, fists strike across to left and rear, fist-eye backwards, look in direction of left fist;

(六)搬攔捶

6. Block, Parry, Punch

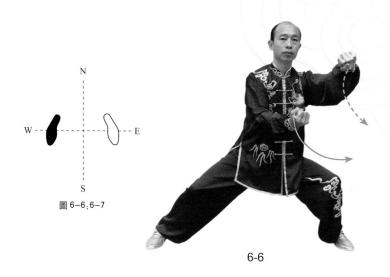

3 劃弧翻拳 身體微右轉再左轉,兩臂順時針 劃弧,兩拳收至左胯旁,拳眼向后,目視左 拳方向(圖 6-6,6-7),

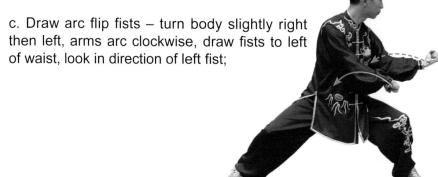

(六)搬攔捶

6. Block, Parry, Punch

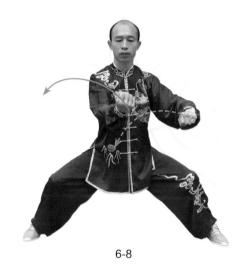

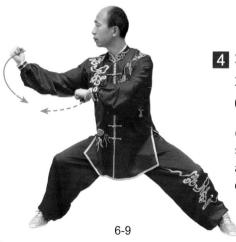

- 4 右轉横擊 身體右轉,重心右移,兩拳向右后方横擊,拳眼向后,目視右拳方向(圖 6-8;6-9)。
 - d. Right turn strike across turn body right, shift weight right, fists strike across to right and rear, fist-eye backwards, look in direction of right fist.

7. Protect heart with fists

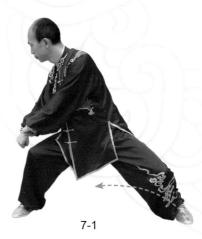

- **1** 右轉栽拳 身體右轉,兩拳向右后方下栽,目視兩拳方向(圖 7-1);
 - a. Right turn plant fists turn body right, plant fists downwards to the right and rear, look in direction of the fists;

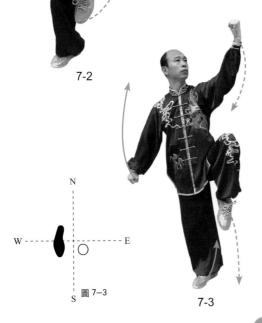

- **2** 躍轉掄臂 提左膝,右腳蹬地躍起,兩臂掄轉,目視左拳方向(圖7-2;7-3);
 - b. Twist jump swing arms raise left knee, drive and leap from right foot, swing arms around, look in direction of left fist;

(七)護心捶

7. Protect heart with fists

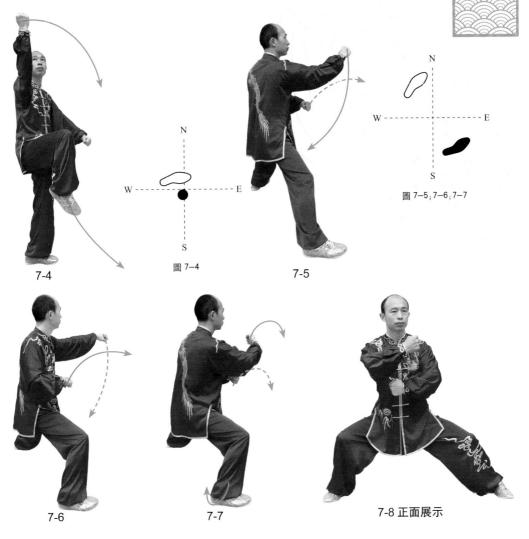

- 3 劃弧合臂 跳至東北方向,身體先右轉再左轉,重心右移,兩臂螺旋纏繞,右臂在上,兩拳拳眼向上,成右偏馬步,目視前方(圖7-4;7-5;7-6;7-7;7-8)。
 - c. Draw arc close arms land facing north-east, turn body first right then left, shift weight right, arms wind around one another, right arm uppermost, fist-eyes upwards, adopt a right-biased horse stance, look ahead.

(八)白鶴亮翅

8. White Crane Flashes its Wings

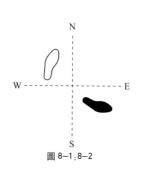

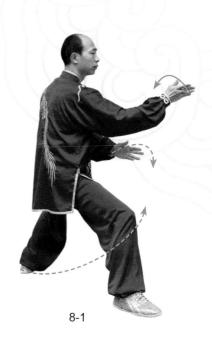

8-2 正面展示

- **1** 兩拳變掌 身體右轉,重心左移,右腳以前腳掌爲軸碾轉,同時兩拳螺旋變掌,目視兩掌方向(圖 8-1,8-2);
 - a. Fists become palms turn body right, shift weight left, roll right foot around on ball of foot as axis, at the same time both fists spiral and become palms, look in direction of the palms;

(八)白鶴亮翅

8. White Crane Flashes its Wings

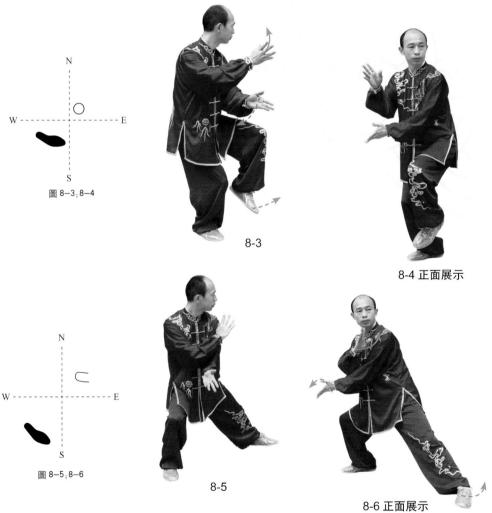

- 2 擦腳合臂 重心右移,提左腳,向左前方擦出,兩臂相合,目視左腳方向(圖 8-3.8-4.8-5.8-6).
 - b. Slide foot close arms shift weight right, lift left foot, slide out to the left and front, bring arms together, look in direction of left foot;

(八)白鶴亮翅

8. White Crane Flashes its Wings

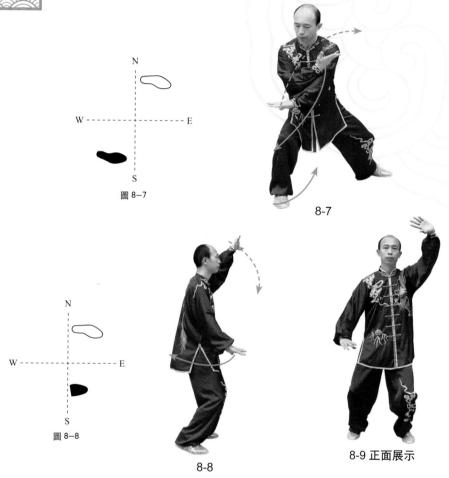

- **③ 收腳分掌** 身體左轉,重心左移,左掌内旋,兩掌上下斜分,左掌在左額斜上方,掌心向外,右掌收至右膝上方,掌心向下,同時右腳收至左腳內側,成虚步,目視前方(圖 8-7;8-8;8-9)。
 - c. Close feet part palms turn body left, shift weight left, separate palms up and down, left palm to the upper left of the forehead, palm facing outwards, draw right palm above right knee, palm facing downwards, at the same time draw right foot to inside of left foot, adopt an empty stance, look ahead.

(九)斜行拗步

9. Oblique Stance with Twist Step

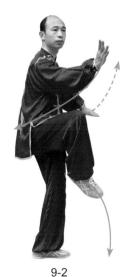

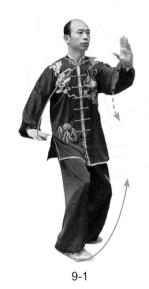

- **1** 右轉擺掌 身體右轉,左掌向右撥擋,右掌隨 腰轉至右胯旁,目視左掌方向(圖 9-1);
 - a. Right turn swing palm turn body right, left palm push right and block, right palm follows beside hip as waist turns right, look in direction of left palm;

2 左轉提膝 身體左轉,提右膝,右掌向左撥 擋,左掌隨腰轉至左胯旁,目視右掌方向(圖 9-2);

b. Left turn lift knee – turn body left, lift right knee, right palm push right and block, left palm follows beside hip as waist turns left, look in direction of right palm;

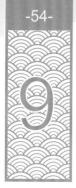

(九)斜行拗步

9. Oblique Stance with Twist Step

- **3 震腳擦步** 身體右轉,右腳下震于左腳内側,同時左腳向左前方擦出, 左掌向右撥擋,右掌摟膝收至右胯旁,目視左掌方向(圖 9-3,9-4),
 - c. Thud foot slide step turn body right, drop right foot with a thud to inside of left foot, at the same time slide left foot out to the left and front, left palm push right and block, draw right palm past knee beside hip, look in direction of left palm;

(九)斜行拗步

9. Oblique Stance with Twist Step

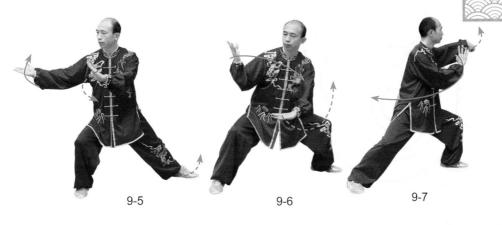

- 4 左轉提勾 身體左轉,重心左移,左掌向左摟膝變勾手,右掌經耳側向左推出,目視右掌方向(圖 9-5;9-6;9-7);
 - d. Turn left raise hook turn body left, shift weight left, draw left palm left and form hook, push right palm past ear out to left, look in direction of right palm;

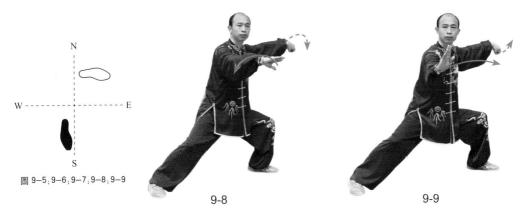

- **5 弓步立掌** 身體右轉,重心不移,成左弓步,右掌向右横拉,立掌,目視右掌方向(圖 9-8,9-9)。
 - e. Bow stance palm upright turn body right, centre weight, adopt left bow stance, draw right palm across to the right, turn palm upright, look in direction of right palm.

(十)提收

10. Lift and retract

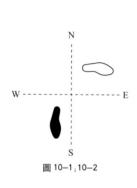

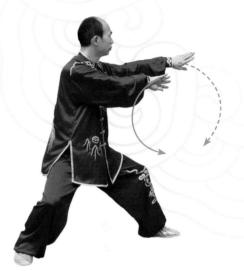

10-1

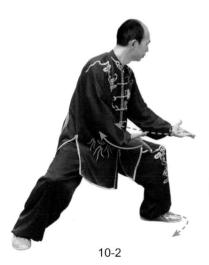

- 1 右移合臂 身體左轉,重心右移,同時左勾 手變掌,兩掌相合,手背相對,目視兩掌方 向(圖 10−1);
 - a. Shift right close arms turn body left, shift weight right, at the same time left hook becomes palm, the two palms close together, backs of hands facing each other, look in direction of the palms;
- **2 左移合臂** 重心左移,兩臂翻轉,掌心相對, 目視兩掌方向(圖 10-2);
 - b. Shift left close arms shift body left, flip both arms, palms facing each other, look in direction of the palms;

(十)提收

10. Lift and retract

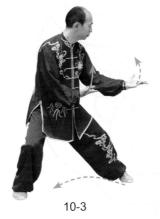

c. Draw palms draw foot – turn body right, shift weight right, draw left foot to inside of right foot, draw hands together to chest, palms facing inwards, look in direction of the palms;

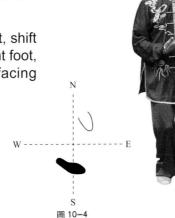

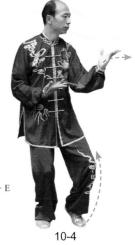

d. Lift knee press down – turn body left, lift left knee, at the same time flip both palms, press forwards and downwards, look in direction of the palms.

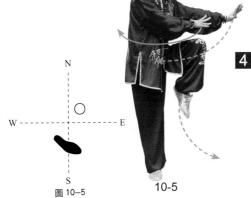

(十一)前趟

11. Wade Forward

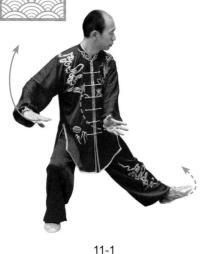

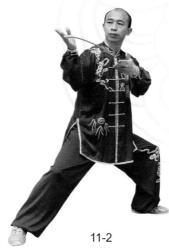

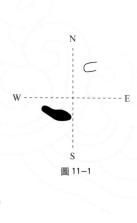

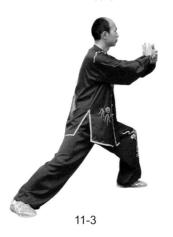

- 1 屈膝擦腳 身體右轉,右腳屈膝,左腳向左前方擦出,同時兩掌向右后方下捋,目視左腳方向(圖 11-1);
 - a. Bend knee slide foot turn right, bend right knee, slide left foot out to the left and front, at the same time pull both palms down to the right and rear, look in direction of the left foot;

- **2** 旋掌前擠 身體左轉,重心左移,兩掌旋轉相搭,掌心相對,弓步前擠,目視兩掌方向(圖 11-2,11-3);
 - b. Spin palms press forward turn body left, shift weight left, palms whirl together, facing each other, bow stance press forwards, look in direction of the palms;

(十一)前趟

11. Wade Forward

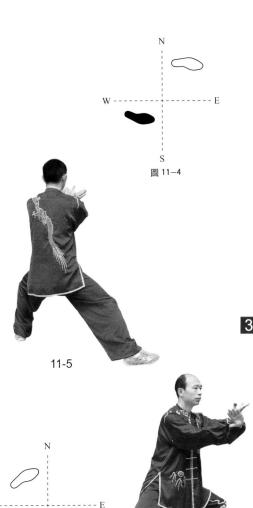

圖 11-5:11-6

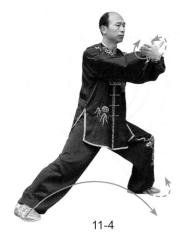

- 3 翻掌擦腳 身體微右轉再左轉,兩 掌翻轉,掌背相對,右腳走内弧向 右前方擦出,目視右腳方向(圖 11-4,11-5,11-6);
 - c. Flip hands slide foot turn body slightly right then left, flip both palms, backs together, draw right foot in an inward arc and slide out to the front and right, look in direction of right foot;

11-6 正面展示

(十一)前趟

11. Wade Forward

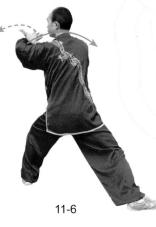

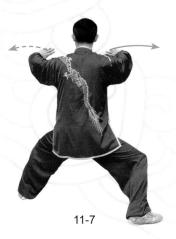

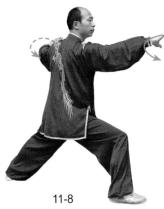

- 4 馬步分掌 身體微左轉再右轉,重心右移,同 時右掌内旋,兩臂分展,成右偏馬步,目視正 前方(圖11-6,11-7,11-8,11-9,11-10)。
 - d. Horse stance part palms turn body slightly left then right, shift weight right, at the same time rotate right palm inwards, spread arms apart, adopt a right-biased horse stance, look straight ahead.

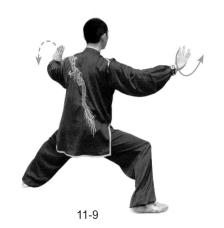

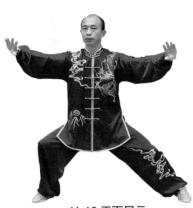

11-10 正面展示

(十二)右掩手肱捶

12. Hide Hand and Strike with Fist (Right Side)

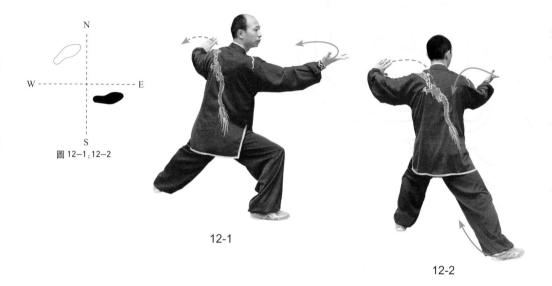

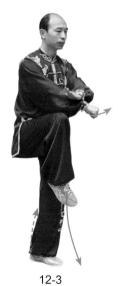

- 1 提膝合臂 微右穿掌,身體左轉再右轉,提右 膝. 右掌變拳, 兩臂相合, 右拳在下, 目視兩 手方向(圖12-1:12-2:12-3):
 - a. Lift knee close arms slightly point right palm. turn body left then right, raise right knee, right palm becomes fist, arms come together, right fist below, look in direction of the hands:

(十二)右掩手肱捶

12. Hide Hand and Strike with Fist (Right Side)

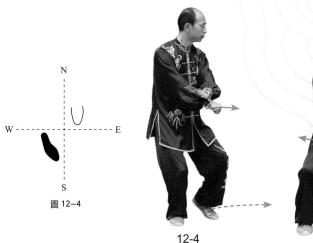

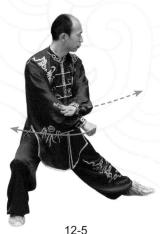

- **2** 震腳擦腳 右腳下震于左腳内側,同時左 腳向左前方擦出,目視左腳方向(圖 12-4,12-5);
 - b. Thud foot slide foot-drop right foot with a thud to inside of left foot, at the same time slide left foot out to the left and front, look in direction of left foot;

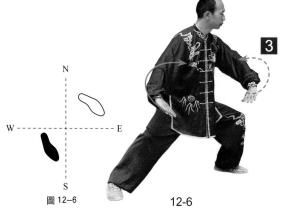

- 3 左移分掌 身體左轉,重心左移,襠 走下弧,兩臂螺旋分開,目視左掌方 向(圖 12-6);
 - c. Shift left part palms turn body left, shift weight left, dip pelvis in a downward arc, both arms spiral apart, look in direction of left palm;

-63

(十二)右掩手肱捶

12. Hide Hand and Strike with Fist (Right Side)

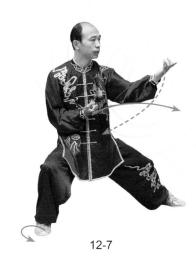

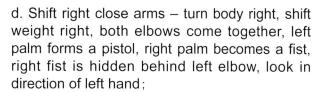

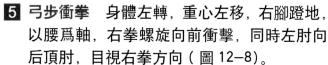

e. Bow stance punch fist – turn body left, shift weight left, thrust right foot, with waist as axis, right fist spirals forward in a punch strike, at the same time left elbow jabs backwards, look in direction of right fist.

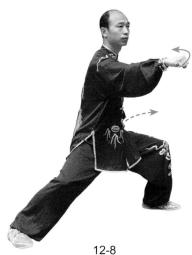

(十三)披身捶

13. Fists roll over body

1 左轉旋臂 身體左轉,右臂外旋向左,同時 左槍手變拳内旋與右臂相配合,目視左拳方 向(圖 13-1);

a. Left turn swing arm – turn body left, swing right arm outwards to the left, at the same time left pistol becomes fist swinging inwards in coordination with right arm, look in direction of left fist:

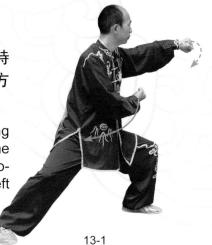

2 右轉旋臂 身體右轉,重心右移,同時兩臂螺旋向右旋轉,目視右拳方向(圖 13-2;13-3);

c. Right turn swing arm – turn body right, shift weight right, at the same time the two arms spiral and whirl to the right, look in direction of right fist;

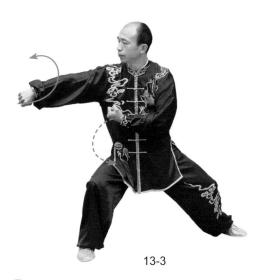

(十三)披身捶

13. Fists roll over body

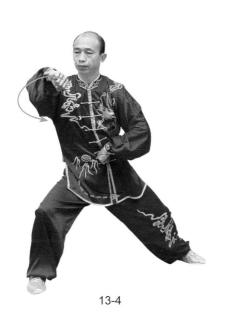

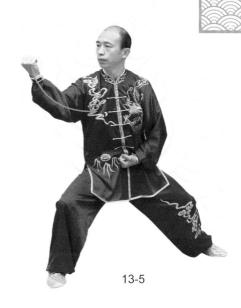

3 外旋滚壓 身體左轉,重心左移,右臂外旋, 以前臂爲力點向左滚壓,左拳收至左腰側, 目視右拳方向(圖13-4,13-5,13-6)。

d. Swing outwards roll press – turn body left, shift weight left, swing right arm outwards, roll left with point of force in forearm, draw left fist beside left waist, look in direction of right fist.

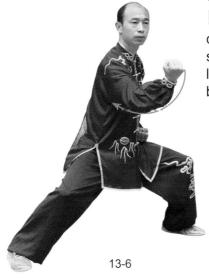

(十四)背折靠

14. Back-twist butt

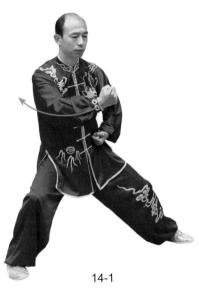

11 右臂内旋 身體右轉再左轉,以腰帶臂,右 臂内旋,目視右拳方向(圖 14-1;14-2);

a. Right arm swing inwards - turn body right then left, waist leads arm, swing right arm inwards, look in direction of right fist;

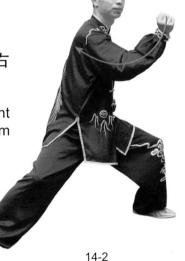

(十四)背折靠

14. Back-twist butt

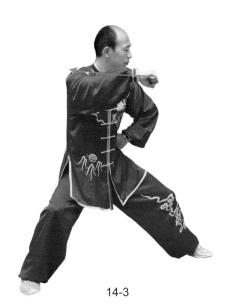

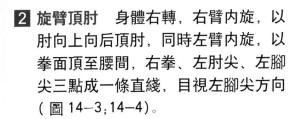

b. Rotate arm jab elbow – turn body right, rotate right arm inwards, jab elbow upwards and backwards, so that right fist, left elbow tip, left toes form three points on a line, look in direction of left toes.

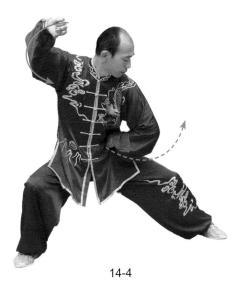

(十五)青龍出水

15. Green Dragon Emerging from the Water

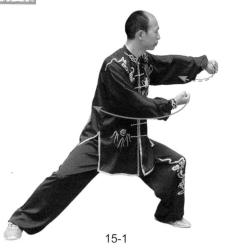

1 左轉旋臂 身體左轉, 重心左移, 兩臂外旋, 目視左拳方向(圖15-1);

a. Left turn swing arms - turn body left, shift weight left, swing both arms outwards, look in direction of left fist:

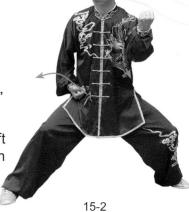

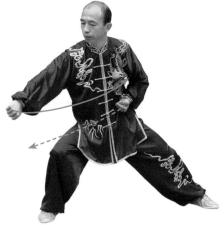

- **2** 右轉旋臂 身體右轉, 重心右移, 左臂外旋,右臂内旋,目視右拳方 向(圖15-2:15-3):
 - b. Right turn swing arms turn body right, shift weight right, swing left arm outwards, swing right arm inwards, look in direction of right fist;

(十五)青龍出水

15. Green Dragon Emerging from the Water

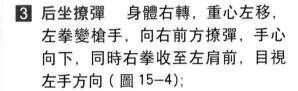

c. Sit back and flick – turn body right, shift weight left, left fist forms a pistol, flick to the right and front, palm facing downwards, at the same time draw right fist to left shoulder, look in direction of left hand;

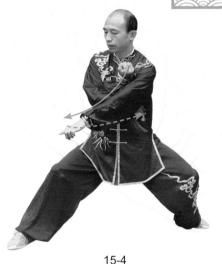

4 前移崩拳 身體左轉,重心右移,右拳以 拳輪爲力點側崩拳,同時左槍手收至左腰 側,目視右拳方向(圖15-5)。

d. Shift forwards drop-swing fist – turn body left, shift weight right, drop-swing right fist with point of force in outer edge of fist,at the same time, the left hand to the left waist, look in direction of right fist.

(十六)斬手

16. Chop with Hand

1 擺腳翻掌 身體先左轉再右轉,重心左移, 右臂外旋,右拳變掌,左槍手變掌外旋,同 時右腳提起,腳跟先着地,腳尖外擺,目視 右掌方向(圖16-1;16-2;16-3);

a. Swing foot flip palm – turn body left then right, shift weight left, swing right arm outwards, right fist becomes palm, left pistol becomes palm and turns outwards, at the same time lift right foot, land with heel first, swing toes outwards, look in direction of right palm;

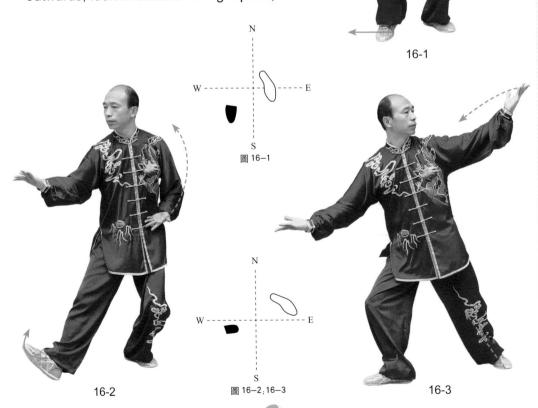

(十六)斬手

16. Chop with Hand

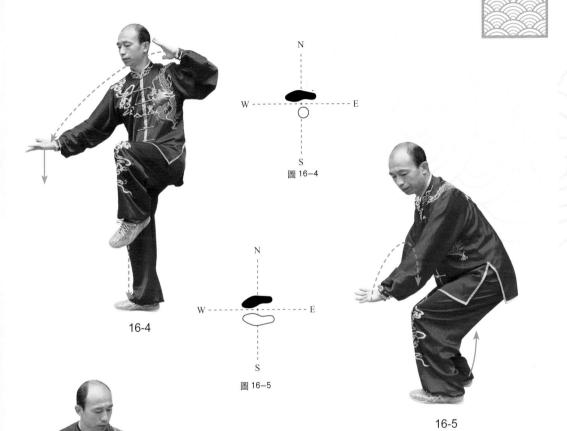

2 震腳切掌 身體右轉,提左腳下震于右腳內側,腳尖 微內扣,同時左掌經左耳側切于右掌前端,身體下蹲, 目視兩手方向(圖 16-4,16-5,16-6)。

b. Thud foot slice palm – turn body right, raise left foot, drop with a thud to inside of right foot, toes turned slightly inwards, at the same time slice left palm past left ear and across face of right palm to a stop, squat downwards, look in direction of the hands.

16-6 正面展示

(十七)翻花舞袖

17. Turn out flowers and brandish sleeves

身體左轉, 兩掌逆時針翻轉, 同時提 1 翻轉提膝 右膝, 目視左掌方向(圖 17-1,17-2);

a. Turn over lift knee - turn body left, flip both palms counterclockwise, at the same time raise right knee,

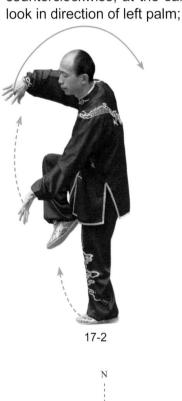

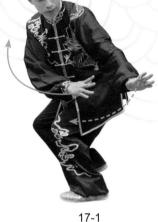

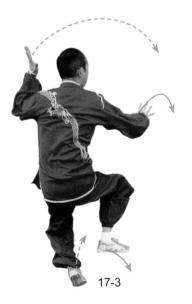

(十七)翻花舞袖

17. Turn out flowers and brandish sleeves

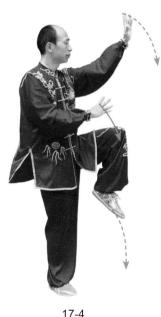

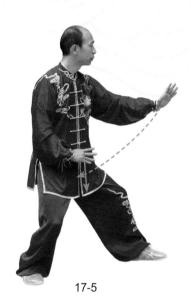

17-4

圖 17-5

- 2 躍轉掄劈 身體向身后跳轉(180°),右腳先着地, 左腳在左前方,重心在右腳,同時兩手順時針掄劈, 左掌在前,目視左掌方向(圖17-3,17-4,17-5)。
 - b. Twist jump swing chop jump and twist around (180°), land first on right foot, then left foot to the left and front, weight on right foot, at the same time swing both hands clockwise and chop, left palm in front, look in direction of left palm.

(十八)海底翻花

18. Turn out flowers from seabed

- **1** 右轉變拳 身體右轉,兩掌變 拳,左拳在外,目視左拳方向(圖 18-1,18-2)。
 - a. Right turn make fist turn body right, palms become fists, left fist outside, look in direction of left fist:

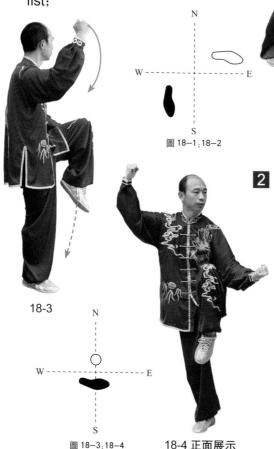

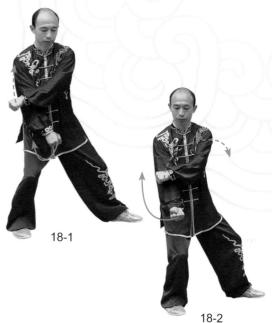

- 2 提膝翻臂 身體左轉,同時提左膝, 高過水平,腳尖下垂,左臂逆時針翻轉, 砸于左膝外側,右臂外旋,向左向上 發力,右拳高與耳平,目視左拳方向 (圖 18-3,18-4)。
 - b. Lift knee flip arms turn body left, at the same time raise left knee, higher than level, toes hanging down, flip left arm counterclockwise, pound to outside of left knee, swing right arm outwards, expressing force up and left, right fist to ear level, look in direction of left fist.

(十九)左掩手肱捶

19. Hide Hand and Strike with Fist (Left Side)

11 震腳合臂 左腳下震于右腳内側,同 時右腳向右前方擦出, 兩臂相合, 右 拳變掌在上,目視兩手方向(圖19-1:19-2:19-3:19-4);

a. Thud foot close arms - drop left foot with a thud to inside of right foot, at the same time slide right foot out to the right and front, arms come together, right fist becomes palm on top, look in direction of the hands:

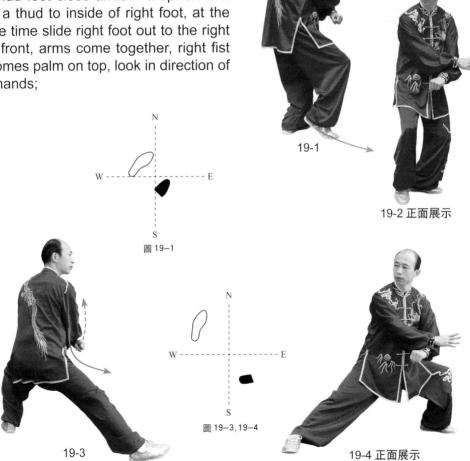

(十九)左掩手肱捶

19. Hide Hand and Strike with Fist (Left Side)

2 右移分掌 身體右轉,重心右移,襠 走下弧,兩臂螺旋分開,目視右掌方 向(圖 19-5;19-6);

 b. Shift right part palms – turn body right, shift weight right, dip pelvis in a downward arc, both arms spiral apart, look in direction of right palm;

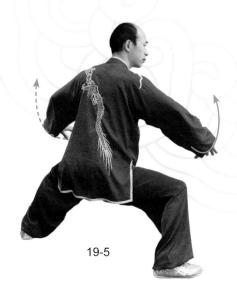

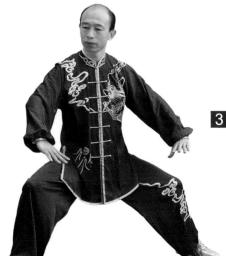

19-6 正面展示

- 3 左移合臂 身體左轉,重心左移,兩肘相合, 右掌變槍手,左拳掩于右肘后側,目視右掌 方向(圖 19-7,19-8);
 - c. Shift left close arms turn body left, shift weight left, both elbows come together, right palm forms a pistol, left fist is hidden behind right elbow, look in direction of right hand;

圖 19-5

-77

(十九)左掩手肱捶

19. Hide Hand and Strike with Fist (Left Side)

- 4 弓步衝拳 身體右轉,重心右移,左 腳蹬地,以腰爲軸,左拳螺旋向前衝擊,同時右肘向后頂肘,目視左拳方 向(圖 19-9;19-10)。
 - d. Bow stance punch fist turn body right, shift weight right, thrust left foot, with waist as axis, left fist spirals forward with a punch strike, at the same time right elbow jabs backwards, look in direction of left fist.

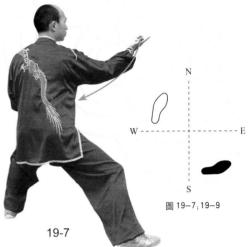

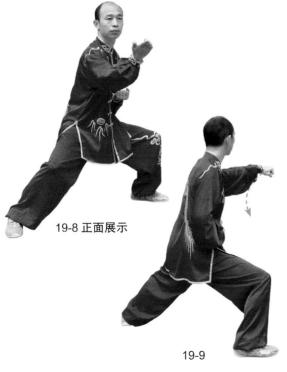

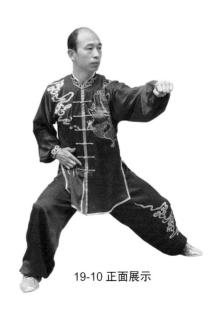

(二十) 左六封四閉

20. Six Sealing and Four Closing (Left Side)

- 1 變掌下捋 身體左轉,重心左移,左拳變掌, 劃弧下捋,目視左掌方向(圖 20-1,20-2,20-3);
 - a. Make palm pull down turn body left, shift weight left, left fist becomes palm, pull in a downwards arc, look in direction of left palm;

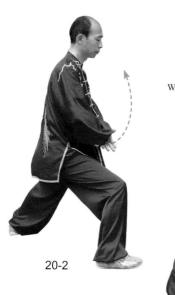

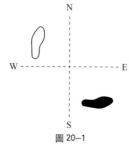

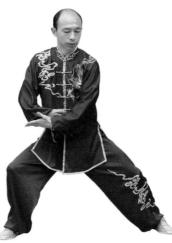

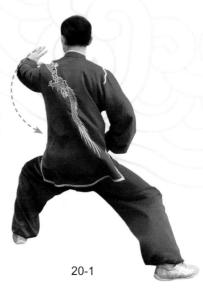

(二十) 左六封四閉

20. Six Sealing and Four Closing (Left Side)

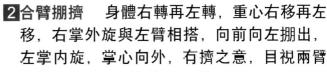

方向(圖20-4;20-5;20-6);

b. Close arms lift push – turn body right then left, shift weight right then left, rotate right palm outwards and bring left arm to join it, lift outwards to the front and left, rotate left palm inwards, palm facing outwards, as if in a crowd, look in direction of the arms;

20-7

20-8

圖 20-8

(二十) 左六封四閉

20. Six Sealing and Four Closing (Left Side)

3 擺腳刁托 身體右轉,重心右移,右腳尖外擺, 左腳上步,腳尖點地成虚步,同時右掌變刁手劃 弧至右耳側,左手劃弧托掌于左肩前,目視左掌 方向(圖 20-7,20-8,20-9,20-10);

c. Swing foot grip lift – turn body right, shift weight right, swing right toe outwards, step left foot forwards, rest on tips of toes and adopt empty stance, at the same time grip with right palm and draw in an arc to right ear, lift with left hand to front of left shoulder, look in direction of left palm;

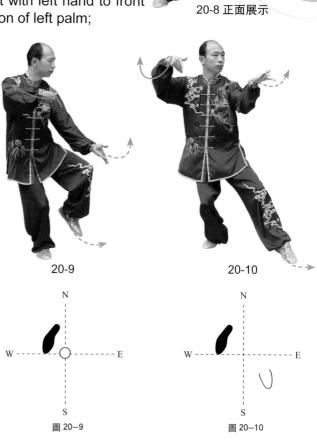

(二十)左六封四閉

20. Six Sealing and Four Closing (Left Side)

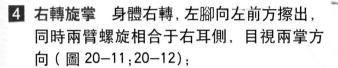

d. Right turn rotate palm – turn body right, slide left foot out to left and front, at the same time both arms spiral and come together beside right ear, look in direction of the palms;

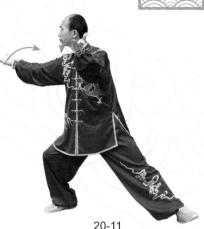

5 虚步按掌 兩掌前向左、向下按掌,同時右腳 收至左腳内側,成虚步,目視兩掌方向(圖 20-13)。

e. Empty stance press palms – both palms forward to left, press palms down, at the same time bring right foot to inside of left foot, look in direction of the palms.

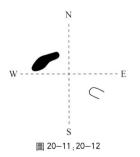

20-13

(二十一)右單鞭 21. Single Whip (Right Side)

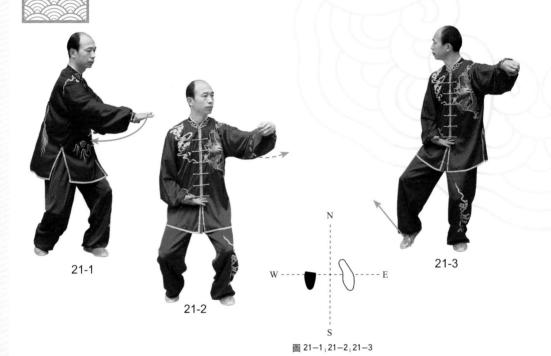

- **1** 左轉推收 身體左轉,右手向左前下方推壓,左手回收和右手形成對拉, 目視右手方向(圖 21-1);
 - a. Left turn push pull turn body left, push right hand forwards and downwards and pull left hand back, the two hands an opposing pair, look in direction of right hand:
- **2** 右轉提勾 身體右轉,左掌變勾手,向左前方頂出,以腕部爲力點,同時右掌收至腹前,掌心向上,目視左勾手方向(圖 21-2,21-3),
 - b. Right turn rising hook turn body right, left palm becomes hook, push upwards and outwards to front and left, point of force in the wrist, at the same time draw right hand in front of belly, look in direction of left hook;

(二十一)右單鞭

21. Single Whip (Right Side)

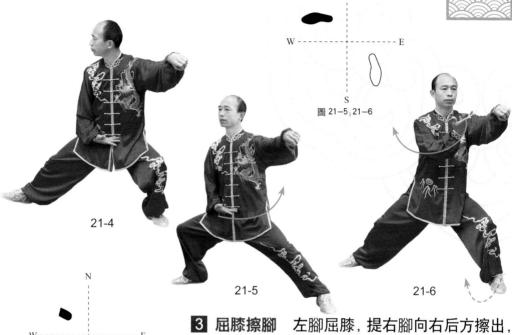

- 3 屈膝擦腳 左腳屈膝,提右腳向右后方擦出 目視右腳方向(圖 21-4);
 - c. Bend knee slide foot bend left knee, lift right foot and slide out to the right, look in direction of right foot;
- 4 重心右移 身體右轉,重心右移,襠走下弧,目視前方(圖 21-5);

圖 21-4

- d. Shift weight right turn body right, shift weight right, dip pelvis in a downward arc, look ahead;
- **5** 左移穿掌 身體左轉,重心左移,右掌向左勾手方向穿出,目視右手方向(圖 21-6):
 - e. Shift left cross palms turn body left, shift weight left, right palm crosses over left hook, look in direction of right hand;

(二十一)右單鞭

21. Single Whip (Right Side)

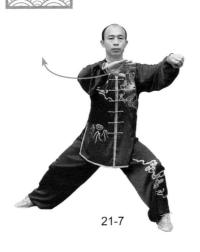

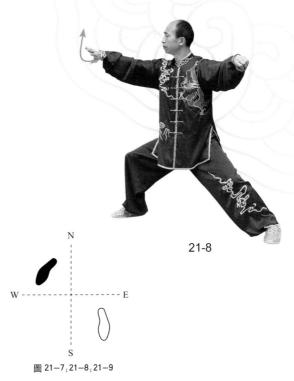

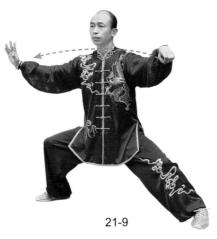

- 6 横拉立掌 身體右轉,重心右移,同時右掌内旋,向右横拉,立掌,成右偏馬步,目視前方(圖 21-7,21-8,21-9)。
 - f. Draw across palm upright turn body right, shift weight right, at the same time rotate right palm inwards, draw across to right, turn palm upright, adopt a right-biased horse stance, look ahead.

22. Wave Hands like Clouds (Right Side)

a. Close feet swing palms – turn body slightly right then left, shift weight left, both arms whirl clockwise, draw to front of body, at the same time draw right foot to inside of left foot, rest on tips of toes, adopt empty stance, look in direction of right palm;

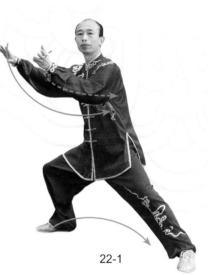

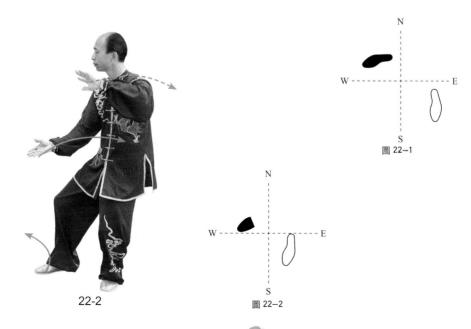

22. Wave Hands like Clouds (Right Side)

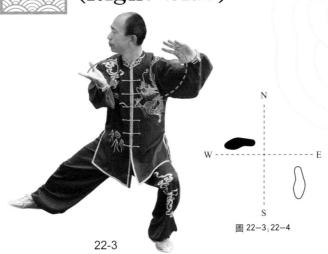

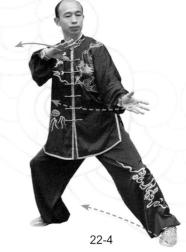

- 2 開步推掌 右腳向右后方擦出,同時兩掌 向左前方平推,力達掌根,目視右腳方向 (圖 22-3);
 - b. Open step push palms slide right foot out to right and rear, at the same time push both palms level to the front, and left, expressing force through base of the palms, look in direction of the right foot;
- 3 **叉步旋掌** 身體右轉,重心右移,左腳從右腳后方插出,成叉步,同時兩手向右旋掌,目視右掌方向(圖 22-4,22-5);
 - c. Cross step circle arms turn body right, shift weight right, cross left foot behind right foot, adopt cross step, at the same time both hands circle right, look in direction of right palm:

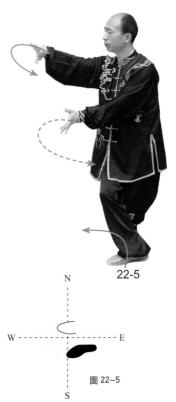

22. Wave Hands like Clouds (Right Side)

4 開步旋掌 身體左轉,重心左移,右腳向右后方擦出, 同時兩手向左旋掌,目視右腳方向(圖 22-6,22-7);

d. Open step circle arms – turn body left, shift weight left, slide right foot out to rear and right, at the same time both hands circle left, look in direction of right foot;

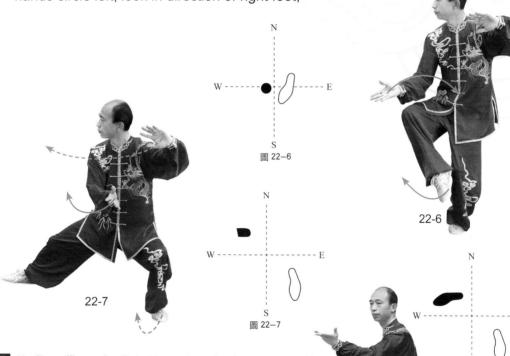

5 旋掌平帶 身體右轉,重心右移,左掌外旋向右平帶,掌心向上,右臂内旋收至右胯旁,掌心向下,目視左掌方向(圖 22-8);

e. Flip palms draw level – turn body right, shift weight right, rotate left palm outwards and draw level to right, palm facing upwards, rotate right arm inwards and draw beside right hip, palm facing downwards, look at left palm;

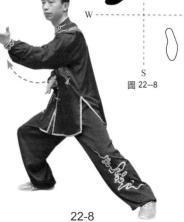

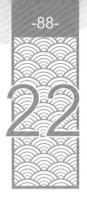

22. Wave Hands like Clouds (Right Side)

6 提膝横擊 身體左轉,重心左移,右臂屈肘壓在左臂上,身體右轉,右臂翻轉,掌心向上,左臂内旋從右腋下向左前方横擊,同時提右膝,腳尖下垂,目視左掌方向(圖 22-9,22-10,22-11)。

f Lift knee horizontal strike – turn body left, shift weight left, bend right elbow pressing on left arm, turn body right, flip right arm, palm facing upwards, rotate left arm inwards in right armpit and make a horizontal strike down to the left and front, at the same time lift right knee, toes hanging down, look at left palm.

(二十三)左雲手

23. Wave Hands like Clouds (Left Side)

- 1 震腳旋掌 右腳下震于左腳内側,兩掌螺旋收至體前,同時左腳跟提起,成虚步,目視左掌方向(圖 23-1);
 - a. Foot thud swing palms drop right foot with a thud to the inside of the left foot, spiral both arms and draw to front of body, at the same time lift left heel, adopt empty stance, look in direction of left palm;

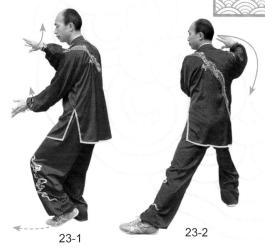

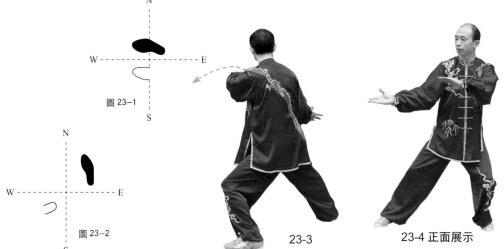

- **2** 開步推掌 左腳向左前方擦出,同時兩掌向右后方平推, 力達掌根,目視兩掌方向(圖23-2);
 - b. Open step push palms slide left foot out to the left and front, at the same time push both palms level to the right and rear, expressing force through base of the palms, look in direction of the palms;

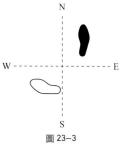

(二十三)左雲手

23. Wave Hands like Clouds (Left Side)

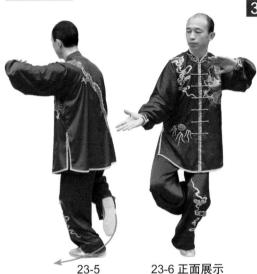

23-6 正面展示

3 叉步旋掌 身體左轉,重心左移,右 腳從左腳后方向左插出,成叉步,同 時兩手向左旋掌,目視左掌方向(圖 23-3,23-4,23-5,23-6,23-7,23-8:23-9:23-10):

c. Cross step circle arms - turn body left, shift weight left, cross right foot behind left foot, adopt cross-step, at the same time both hands circle left, look in direction of left palm:

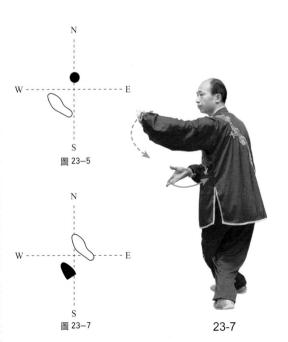

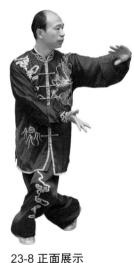

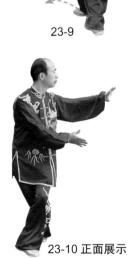

(二十三)左雲手

23. Wave Hands like Clouds (Left Side)

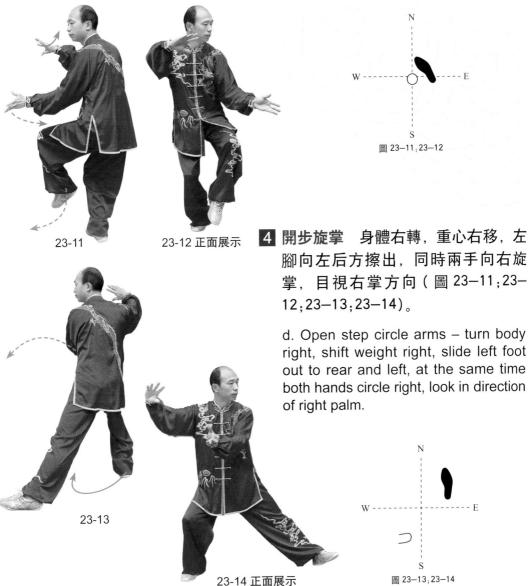

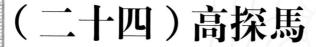

24. High pat (search) on horse

1 左轉旋臂 身體左轉,重心左移,左臂内旋向 左,高與肩平,目視左掌方向(圖 24-1):

a. Left turn swing arm – turn body left, shift weight left, rotate left arm inwards to the left, shoulder level, look in direction of left palm;

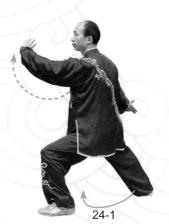

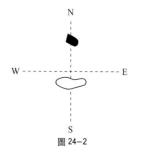

2 擦腳合臂 右腳經左腳内側弧綫向右擦出,同時兩 臂相合,右臂在外,目視右腳方向(圖 24-2);

b. Slide foot close arms – bring right foot in an inward arc past left foot and slide out to the right, at the same time the arms come together, right arm outside, look in direction of the right foot;

(二十四)高探馬

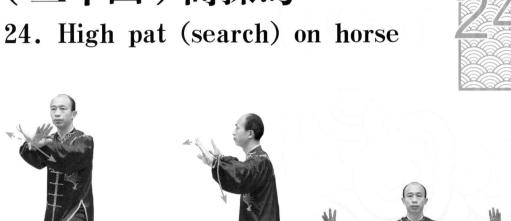

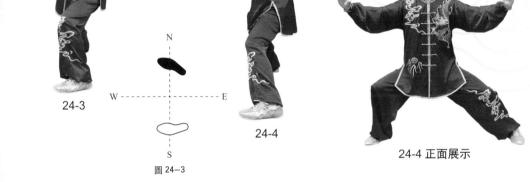

- **3** 馬步分掌 身體微左轉再右轉,重心右移,右掌内旋, 兩臂分展,成右偏馬步,目視前方(圖 24-3;24-4);
 - c. Horse stance part palms turn body slightly left then right, shift weight right, rotate right palm inwards, spread arms apart, adopt a right-biased horse stance, look ahead;
- 4 右轉抱掌 身體右轉,重心左移,右腳尖上翹,兩掌相抱, 左掌在上,目視左掌方向(圖 24-5);
 - d. Right turn hold palm turn body right, shift weight left, lift right toe, palms embrace (as if holding a ball), left palm uppermost, look in direction of left palm;

24-5

(二十四)高探馬

24. High pat (search) on horse

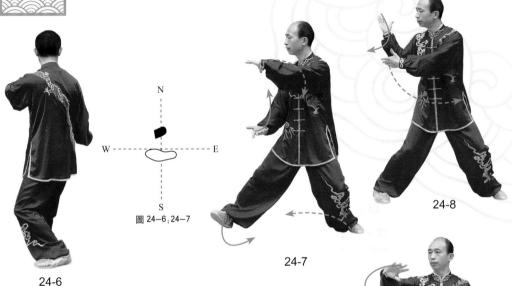

5 虚步推掌 身體左轉,重心右移,右腳內扣,左腳走弧綫收至右腳內側,成虚步,同時兩臂螺旋翻轉,右臂向右横拉立掌,左掌收至腹前,掌心向上,目視右掌方向(圖24-6;24-7;24-8;24-9;24-10)。

e. Empty stance push palm – turn body left, shift weight right, turn right foot inwards, draw left foot in arc to the inside of right foot, adopt empty stance, at the same time arms spiral and flip, draw right arm across to the right, turn palm upright, look in direction of right palm.

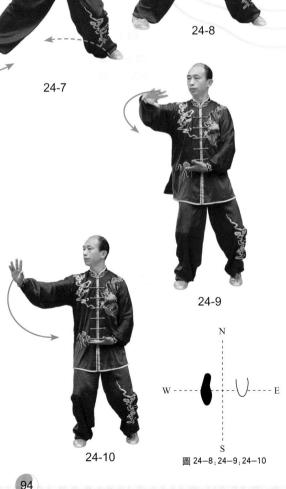

25. Cannonade (Right Side)

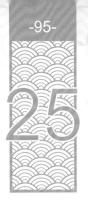

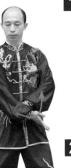

1 左轉下捋 身體左轉,右手向左下捋,同時左手外旋與右臂 相搭,掌心向内,目視兩臂方向(圖 25-1);

a. Left turn pull down – turn body left, pull right hand down to the left, at the same time rotate left hand outwards and bring right arm to meet it, palm facing inwards, look in direction of the arms;

2 掤臂撤步 身體右轉,兩臂向前向右掤出,同時左腳向后撤步,目視兩臂方向(圖 25-2;25-3;25-4);

b. Lift arms withdraw – turn body right, push arms upwards and outwards to front and right, at the same time step backwards with left fact leak in direction of the arms:

with left foot, look in direction of the arms;

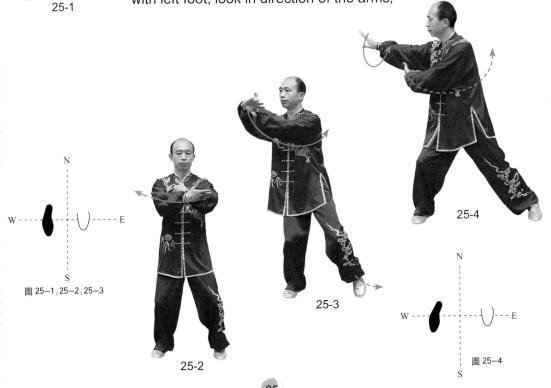

25. Cannonade (Right Side)

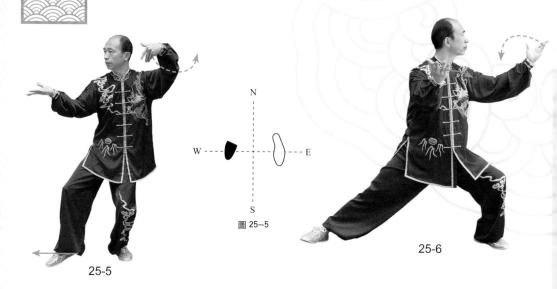

- 3 虚步刁托 身體左轉,重心左移,右腳回收, 腳尖點地成虚步,左掌變刁手收至左耳側,右 掌上托至右肩前,目視右掌方向(圖25-5);
 - c. Empty stance grip lift turn body left, shift weight left, recover right foot, rest on tips of toes and adopt empty stance, grip with left hand and draw beside left ear, lift with right palm up to right shoulder, look in direction of right palm;
- 4 擦腳翻掌 身體左轉,右腳向右擦出,同時兩掌内旋翻轉,收至左肩旁,目視右腳方向(圖 25-6,25-7);
 - d. Slide foot part palms turn body left, slide right foot out to the right, at the same time palms rotate inwards and flip, draw beside left shoulder, look in direction of the right foot;

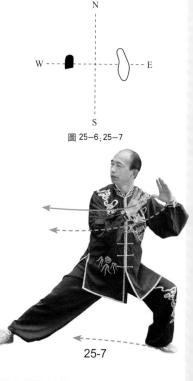

25. Cannonade (Right Side)

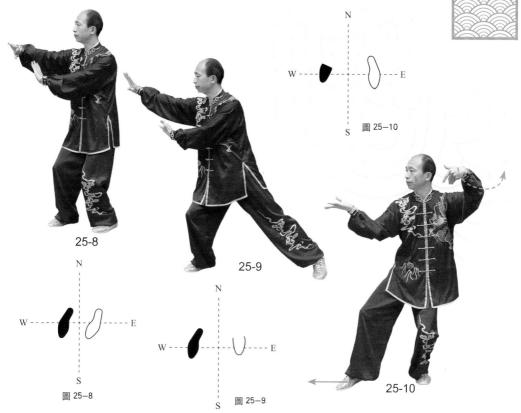

- **5** 跟步前推 身體右轉,左腳跟半步,同時兩掌向右推出,右掌在上,掌指向左,左掌在下,掌指向上,目視兩掌方向(圖 25-8);
 - e. Advance and push forwards turn body right, half step on left heel, at the same time push palms out to the right, right palm above, fingers pointing left, left palm below, fingers pointing up, look in direction of the palms:
- 6 撤步刁托 左腳向后撤步,左掌變刁手收至左耳側,右掌上托至右肩前,同時右腳回收,腳尖點地成虚步,目視右掌方向(圖 25-9;25-10);
 - f. Withdraw grip lift step backwards with left foot, grip with left hand and draw beside left ear, lift with right palm up to right shoulder, at the same time recover right foot, rest on tips of toes and adopt empty stance, look in direction of right palm;

25. Cannonade (Right Side)

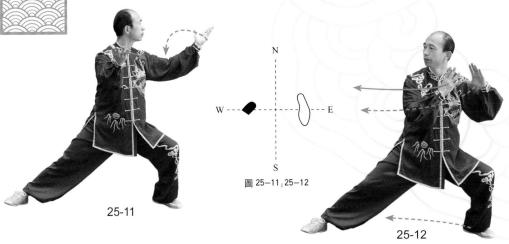

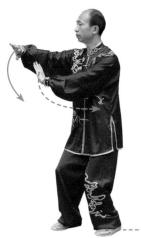

25-13

- 7 擦腳翻掌 身體左轉,右腳向右擦出,同時兩掌内旋翻轉,收至左肩旁,目視右腳方向(圖 25-11,25-12);
 - g. Slide foot part palms turn body left, slide right foot out to the right, at the same time palms rotate inwards and flip, draw beside left shoulder, look in direction of the right foot;
- 8 跟步前推 身體右轉,左腳跟半步,同時兩掌向右推出,右掌在上,掌指向左,左掌在下,掌指向上,目視兩掌方向(圖 25-13)。
 - h. Advance push forwards turn body right, half step on left heel, at the same time push palms out to the right, right palm above, fingers pointing left, left palm below, fingers pointing up, look in direction of the palms.

26. Cannonade (Left Side)

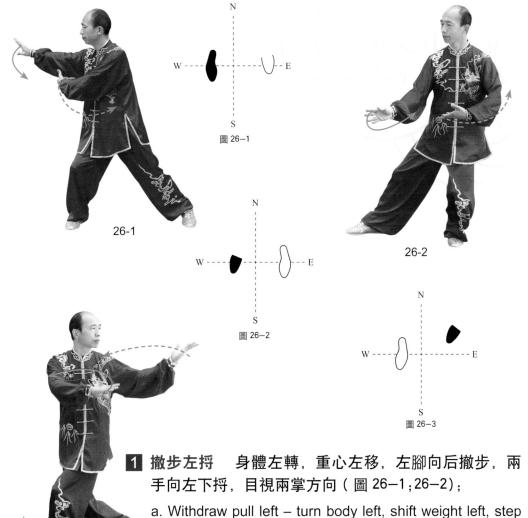

look in direction of the palms;

26-3

backwards with left foot, pull both palms down to the left,

26. Cannonade (Left Side)

2 撤步刁托 身體右轉,重心右移,右腳向后撤步, 兩臂弧形翻轉,右掌變刁手收至右耳側,左掌上托 至右肩前, 同時左腳回收, 腳尖點地成虚步, 目視 左掌方向(圖 26-3:26-4:26-5):

b. Withdraw grip lift – turn body right, shift weight right, step backwards with right foot, flip both arms and follow an arc, grip with right hand and draw beside right ear, lift with left palm up to left shoulder, at the same time recover left foot, rest on tips of toes and adopt empty stance, look in direction of left palm;

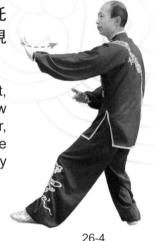

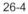

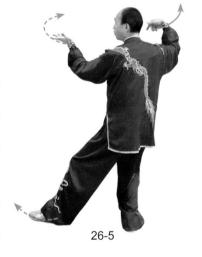

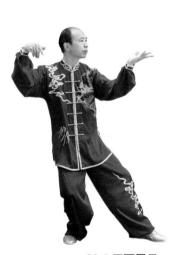

26-5 正面展示

26. Cannonade (Left Side)

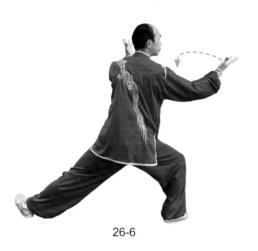

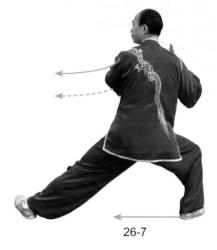

圖 26-6:26-7

3 擦腳翻掌 身體右轉,左腳向左擦出,同時 兩掌内旋翻轉,收至右肩旁,目視左腳方向 (圖 26-6;26-7);

c. Slide foot part palms – turn body right, slide left foot out to the left, at the same time palms rotate inwards and flip, draw beside right shoulder, look in direction of the left foot;

26-7 正面展示

26. Cannonade (Left Side)

4 跟步前推 身體左轉,右腳跟半步,同時兩掌向左推出, 左掌在上,掌指向右,右掌在下,掌指向上,目視兩掌 方向(圖 26-8),

d. Advance push forwards – turn body left, half step on right heel, at the same time push palms out to the left, left palm above, fingers pointing right, right palm below, fingers pointing up, look in direction of the palms;

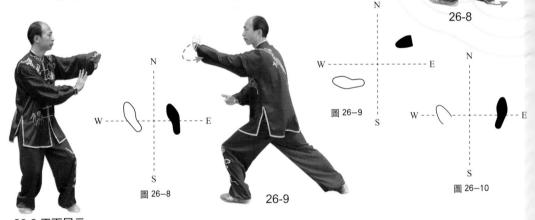

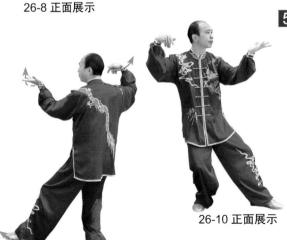

26-10

- 5 撤步刁托 右腳向后撤步,右掌變刁手收至右耳側,左掌上托至左肩前,同時左腳回收,腳尖點地成虚步,目視左掌方向(圖26-9;26-10);
 - e. Withdraw grip lift step backwards with right foot, grip with right hand and draw beside right ear, lift with left palm up to left shoulder, at the same time recover left foot, rest on tips of toes and adopt empty stance, look in direction of left palm;

26. Cannonade (Left Side)

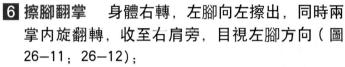

f. Slide foot part palms – turn body right, slide left foot out to the left, at the same time palms rotate inwards and flip, draw beside right shoulder, look in direction of the left foot:

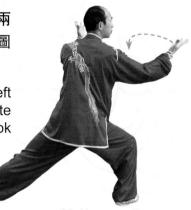

26-11

7 跟步前推 身體左轉,右腳跟半步,同時兩掌向左 推出,左掌在上,掌指向右,右掌在下,掌指向上, 目視兩掌方向(圖 26-13)。

g. Advance push forwards – turn body left, half step on right heel, at the same time push palms out to the left, left palm above, fingers pointing right, right palm below, fingers pointing up, look in direction of the palms.

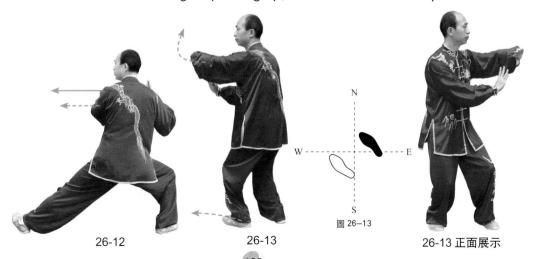

(二十七) 閃通背

27. Flash through Back

1 屈膝分掌 身體右轉,重心右移,右腳屈膝,左腳跟提起兩掌劃弧分開,目視前方(圖 27-1,27-2,27-3),

a.Bend knees part palms –Turn body right, shift weight right, bend right knee, lift left heel, arms arc apart, look ahead;

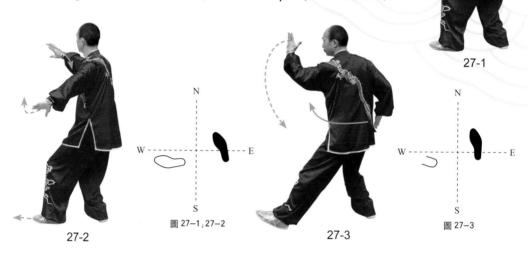

- 2 弓步穿掌 身體左轉,左腳上步變弓步,左 掌劃弧經左膝摟至左胯旁,同時右掌經右腰 向前穿,高與肩平,目視右掌方向(圖 27-4);
 - b. Bow stance cross palms—turn body left, step forward with left foot into bow stance, left palm arcs around brushing left knee to side of left hip, at the same time right palm crosses forward from right waist, shoulder level, look in direction of right palm;

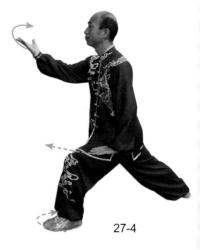

(二十七) 閃通背

27. Flash through Back

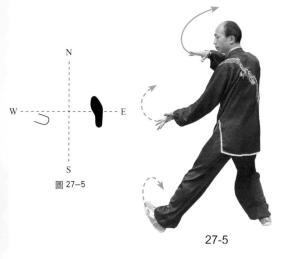

- 3 后坐旋掌 身體右轉,重心右移, 左腳尖内扣,兩臂螺旋翻轉,目視 左掌方向(圖 27-5);
 - c. Sit back rotate palms turn body right, shift weight right, turn left toes inwards, both arms spiral and flip, look in direction of left palm.
- 4 轉身推劈 身體右轉,右腳劃弧向后撤步,同時兩掌 劃弧向前推劈,重心在右腳,目視左掌方向(圖 27-6;27-7;27-8)。
 - d. Turn around push chop turn body right, arc right foot right around and step backwards, at the same time the palms arc forwards to push and chop, weight on right foot, look in direction of left palm.

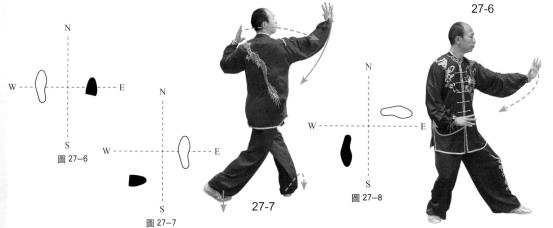

(二十八)指襠捶

28. Strike Groin with Fist

left palm;

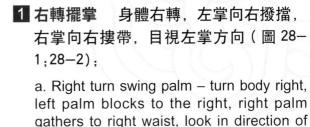

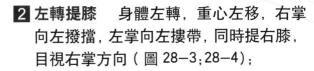

b.Turn left lift knee – turn body left, shift weight left, right palm blocks to the left, left palm gathers to left waist, at the same time lift right knee, look in direction of right palm;

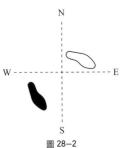

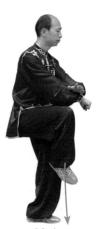

(二十八)指襠捶

28. Strike Groin with Fist

- 3 震腳合臂 右腳下震于左腳内側,同時左腳向左前方擦出,兩臂相合,右掌變拳在下,左掌在上,目視兩手方向(圖 28-5;28-6);
 - c. Thud foot close arms drop right foot with a thud to inside of left foot, at the same time slide left foot out to the left and front, arms come together, right palm becomes fist below, left palm above, look in direction of the hands;

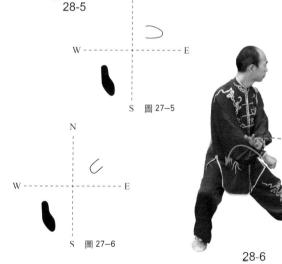

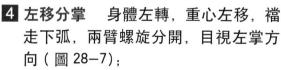

d. Shift left part palms – turn body left, shift weight left, dip pelvis in a downward arc, arms spiral apart, look in direction of left palm;

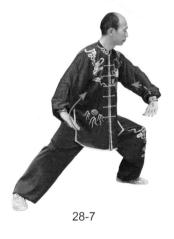

(二十八)指襠捶

28. Strike Groin with Fist

- 5 右移合臂 身體右轉,重心右移,兩肘相合, 左掌變槍手,右掌變拳至右肩前,目視左手 方向(圖 28-8);
 - e. Shift palms close arms turn body right, shift weight right, both elbows come together, left palm forms a pistol, right palm becomes fist beside right shoulder, look in direction of left hand;

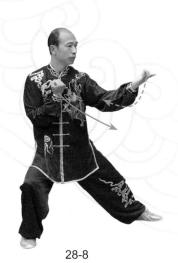

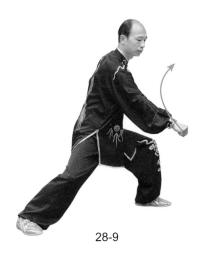

- 6 **弓步衝拳** 身體左轉,重心左移,右腳蹬地,以腰爲軸,右拳螺旋向前下方衝擊,同時左肘向后頂撞,目視右拳方向(圖 28-9)。
 - f. Bow stance punch fist turn body left, shift weight left, thrust right foot, with waist as axis, right fist spirals forward and down in a punch strike, at the same time left elbow jabs backwards, look in direction of right fist.

(二十九)白猿獻果

29. White Ape Offering Fruit

1 轉身左捋 身體左轉,右臂外旋向左下捋,目視右手方向(圖 29-1);

a. Turn around pull left – turn body left, rotate right arm outwards and pull down to the left, look in direction of right hand;

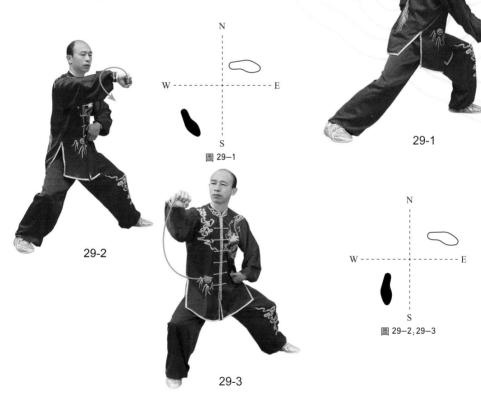

2 右轉掤臂 身體右轉,重心右移,右臂内旋向右向上掤,目視右臂方向(圖 29-2,29-3);

b. Turn right lift arm – turn body right, shift weight right, rotate right arm inwards and lift to the upper right, look in direction of right arm;

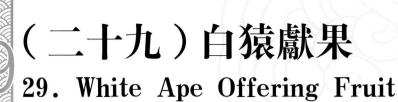

3 提膝舉拳 身體左轉,左腳尖外擺,重心 左移,右拳經腰側上舉,高與鼻平,拳面 向上,同時提右膝,腳尖下垂,左手外 旋變拳于左腰側,目視右拳方向(圖 29-4:29-5:29-6)。

c. Lift knee raise fist – turn body left, swing left toe outwards, shift weight left, raise right fist from beside waist, to nose level, face of fist upwards, at the same time lift right knee, toes hanging down, rotate left hand outwards and make fist beside left waist, look in direction of right fist.

圖 29-5:29-6

29-5

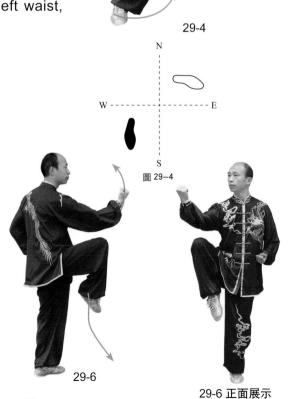

-111-

(三十)雙推手

30. Double Push Hands

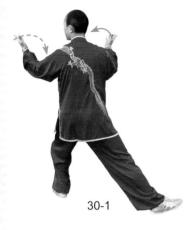

a. Slide foot flip palms – bend left knee, turn body left, slide right foot out to right and front, at the same time both arms spiral and come together beside left ear, look in direction of the palms.

b. Empty stance double push – turn body right, draw left foot to inside of right foot, adopt empty stance, at the same time push both hands out to the front, force expressed through base of palms, shoulder width apart look in direction of the palms.

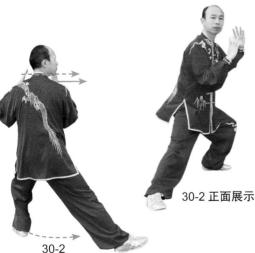

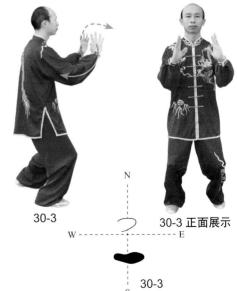

(三十一)中盤

31. Middle Winding

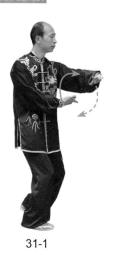

- 1 右轉翻掌 身體右轉,兩掌 翻轉錯開對拉,掌心相對, 左掌在上,重心在右腳,目 視左掌方向(圖 31-1);
 - a. Turn right flip palms turn body right, palms flip and cross as an opposing pair, palms facing one another, left palm above, weight on right foot, look in direction of left palm;

- 2 左轉翻掌 身體左轉,兩掌翻轉 錯開對拉,互换,掌心相對,右 掌在上,重心在右腳,目視右掌 方向(圖 31-2);
 - b. Turn left flip palms turn body left, palms flip and cross in reverse as an opposing pair, palms facing one another, right palm above, weight on right foot, look in direction of right palm;
- **3** 右轉翻掌 身體右轉,兩掌翻轉錯開對拉,互换,掌心相對,左掌在上, 重心在右腳,目視左掌方向(圖 31-3);
 - c. Turn right flip palms turn body right, palms flip and cross in reverse as an opposing pair, palms facing one another, left palm above, weight on right foot, look in direction of left palm;

(三十一)中盤

31. Middle Winding

- 4 左轉穿掌 身體左轉再右轉,右掌從左臂内側螺旋上穿,同時提左膝,兩臂劃弧分開,目視右掌方向(圖 31-4,31-5);
 - d. Turn left point palm turn body left then right, right palm spirals inside left arm pointing upwards, at the same time raise left knee, both arms arc apart, look in direction of right palm;

(三十一)中盤

31. Middle Winding

- **5** 震腳合臂 左腳下震于右腳内側,同時右腳向右擦出,兩臂劃弧相合,高與腰平,目視右腳方向(圖31-6,31-7),
 - e. Thud foot close arms drop left foot with a thud to inside of right foot, at the same time slide right foot out to the right, both arms arc and come together, at waist level, look in direction of right foot;

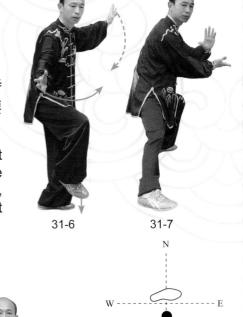

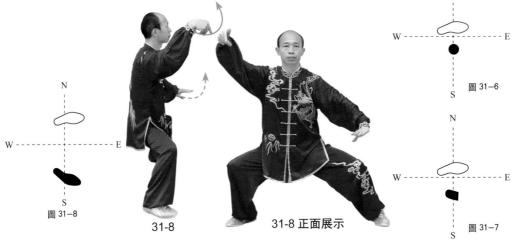

- **⑤ 馬步提手** 身體微左轉再右轉,重心右移,右掌變刁手向右向上提,力達 手腕,高與耳平,左掌與右掌形成對拉至左膝上方,成右偏馬步,目視前 方(圖 31-8)。
 - f. Horse stance raise hand turn body slightly left then right, shift weight right, grip with right hand and raise to the upper right, expressing force through the wrist, to ear level, left palm down beside left knee, the two palms forming an opposing pair, adopt a right-biased horse stance, look straight ahead.

(三十二)前招

32. Forward trick

- 1 右掌内旋 身體右轉再左轉,重心左移,右掌内旋, 左掌隨腰劃平弧,目視右掌 方向(圖 32-1,32-2);
 - a. Right palm rotate inwards turn right then left, shift weight left, rotate right palm inwards, left palm draws a circle at waist level, look in direction of right palm;

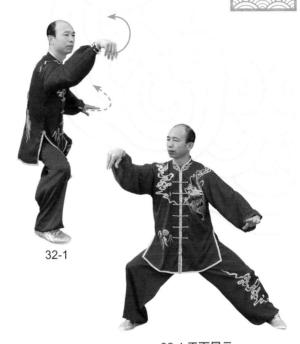

32-1 正面展示

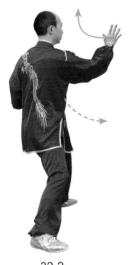

32-2

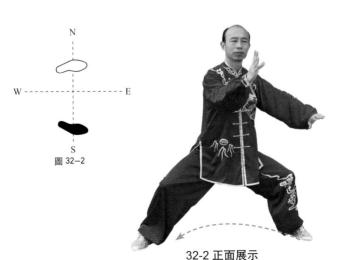

(三十二)前招

32. Forward trick

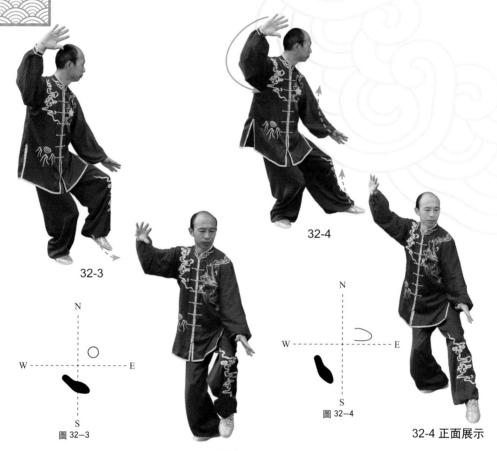

32-3 正面展示

- **② 虚步旋掌** 身體右轉,重心右移,左腳走内弧上步,腳尖點地成虚步, 同時右掌内旋至右額前上方,掌心向外,左掌外旋至左膝上方,掌心斜 向下,目視左掌方向(圖 32-3,32-4)。
 - b. Empty stance rotate palms turn body right, shift weight right, step left foot forward in an inward arc, rest on tips of toes and adopt empty stance, at the same time rotate right palm inwards above and in front of right forehead, palm facing outwards, left palm rotates outwards above left knee, palm tilted downwards, look in direction of left palm.

(三十三)后招

33. Backward trick

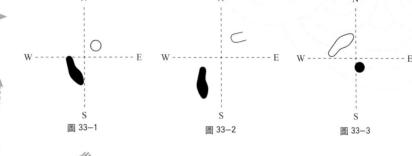

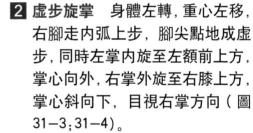

b. Empty stance rotate palms turn body left, shift weight left, step right foot forward in an inward arc, rest on tips of toes and adopt empty stance, at the same time rotate left palm inwards above and in front of left forehead, palm facing outwards, right palm rotates outwards above right knee, palm tilted downwards. look in direction of right palm.

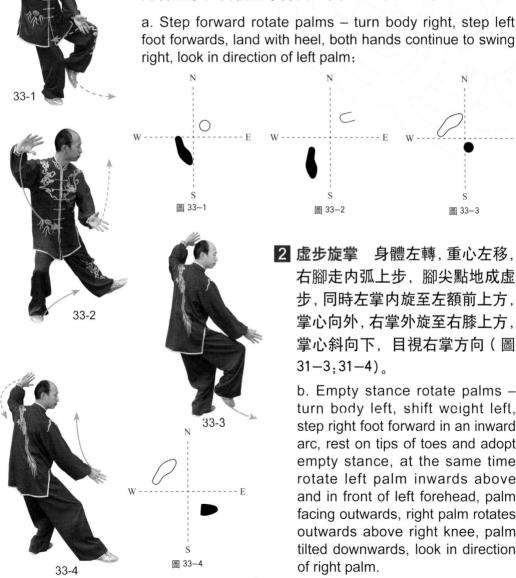

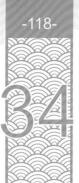

(三十四)右野馬分鬃

34. Part Wild Horse's Mane (Right Side)

身體左轉, 兩臂向左旋轉, 重心在左腳, 目視右掌方向(圖 1 左轉旋臂 34-1):

a. Left turn swing arm – turn body left, arms whirl to the left, weight on left foot, look in direction of right palm;

2 右轉旋臂 身體右轉, 兩臂向右旋轉, 重心 在左腳, 目視左掌方向(圖 34-2);

b. Right turn swing arms - turn body right, arms whirl to the right, weight on left foot, look in direction of left palm;

- 3 左轉提膝 身體左轉, 兩臂向左旋轉, 同時 提右膝、目視右掌方向(圖 34-3)。
 - c. Turn left lift knee turn body left, arms whirl to the left, at the same time lift right knee, look in direction of right palm;

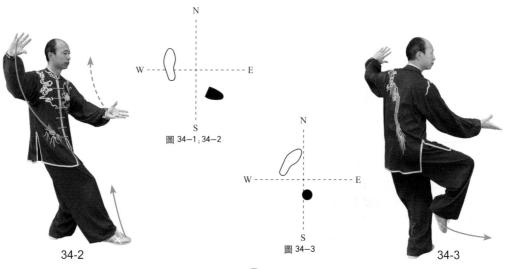

(三十四)右野馬分鬃

34. Part Wild Horse's Mane (Right Side)

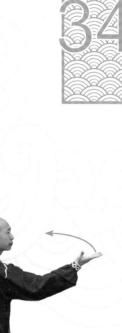

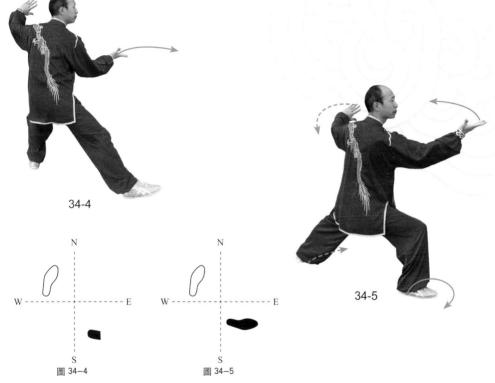

- 4 馬步穿掌 身體右轉,重心右移,右腳向右前方擦出,右掌向右穿靠, 力點在大臂和肩, 左掌向后和右手形成對撑, 成右偏馬步, 目視右 掌方向(圖34-4:34-5)。
 - d. Horse stance cross palms turn body right, shift weight right, slide right foot out to the right and front, right hand points to the right with a shoulder stroke, points of force in the upper arm and shoulder, left palm pushes back and forms an opposing pair with right hand, point of force in the right upper arm and shoulder, adopt a right-biased horse stance, look in direction of right palm.

(三十五) 左野馬分鬃

35. Part Wild Horse's Mane (Left Side)

1 后坐旋掌 身體左轉, 重心左移, 右腳尖 上翹, 兩掌向左旋轉, 目視右掌方向(圖 35-1):

a. Sit back rotate palms - turn body left, shift weight left, raise right toe, both arms whirl to the left, look in direction of right palm;

身體右轉,重心右移,右腳外擺,同時提左膝,兩掌向右旋轉, 2 提膝旋掌 目視左掌方向(圖 35-2:35-3);

 b. Lift knee rotate palms – turn body right, shift weight right, swing right foot outwards, at the same time lift left knee, both arms whirl to the right, look in

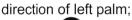

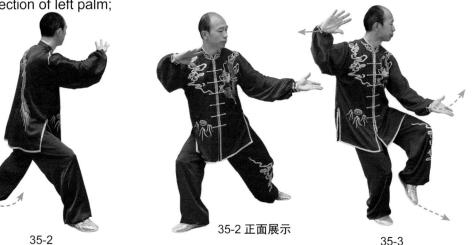

(三十五)左野馬分鬃

35. Part Wild Horse's Mane (Left Side)

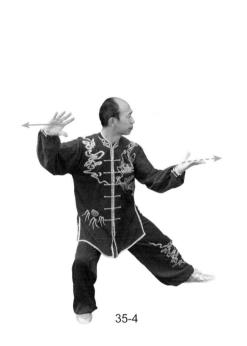

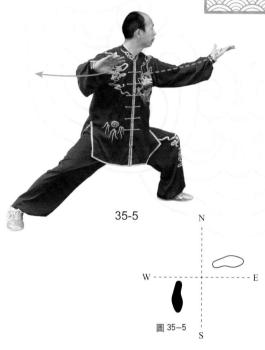

- 3 馬步穿掌 身體左轉,重心左移,左腳向左前方擦出,左掌向左穿靠,力點在大臂和肩,右掌向后和左手形成對撑,成左偏馬步,目視左掌方向(圖35-4,35-5)。
 - c. Horse stance cross palms turn body left, shift weight left, slide left foot out to the left and front,left hand points to the left with a shoulder stroke, points of force in the upper arm and shoulder, right palm pushes back and forms an opposing pair with left hand, point of force in the left upper arm and shoulder, adopt a left-biased horse stance, look in direction of left palm.

36. Fallen lotus (Swing kick drop split)

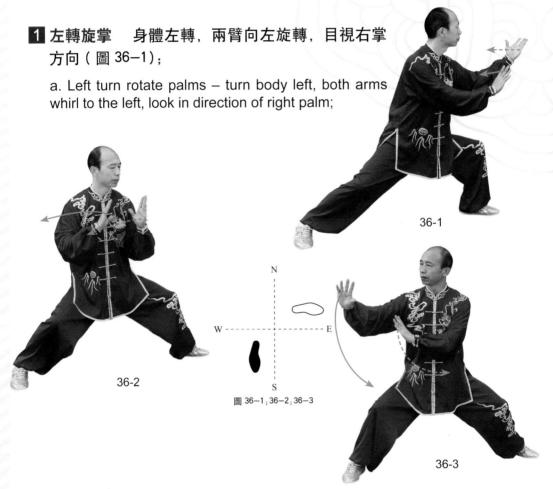

- **2** 右轉旋掌 身體右轉,重心右移,兩掌經體前向右旋轉,掌心斜向下,目 視兩掌方向(圖 26-2; 26-3);
 - b. Right turn rotate palms turn body right, shift weight right, palms pass across front of body and whirl to the right, palms tilted downwards, look in direction of the palms;

36. Fallen lotus (Swing kick drop split)

- **3** 左轉捋按 身體左轉、重心左移、兩掌向左捋按、掌心斜向下、目視 兩掌方向(圖 36-4,36-5);
 - c. Turn left pull press turn body left, shift weight left, palms pull and press to the left, palms tilted downwards, look in direction of the palms;

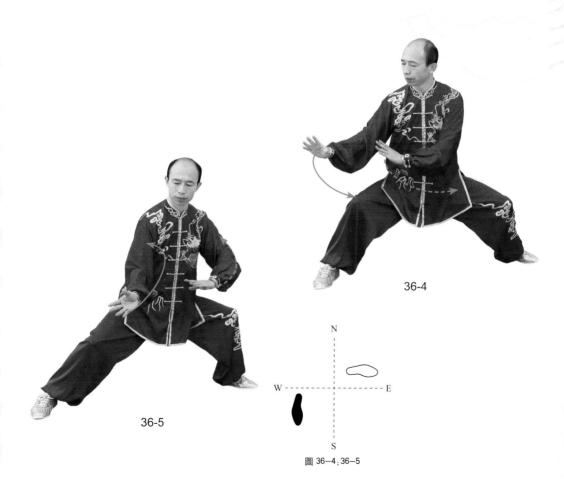

36. Fallen lotus (Swing kick drop split)

4 旋掌收腳 身體左轉再右轉,同時兩掌自左向右旋轉至肩旁,掌心向外,右腳收至左腳内側,目視右掌方向(圖 36-6,36-7,36-8);

d. Swing palms close feet – turn body left then right, at the same time palms rotate from left to right beside shoulder, palms facing outwards, draw right foot to inside of left foot, look in direction of right palm;

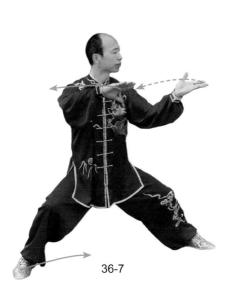

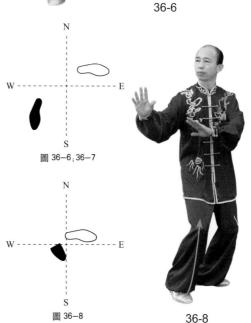

36. Fallen lotus (Swing kick drop split)

5 雙外擺蓮 提右腳, 自左向右做扇形 擺幅, 同時兩掌擊拍腳面, 目視拍腳 方向(圖 36-9,36-10);

e. Double outside swing lotus – lift right foot, swing from left to right in the shape of a fan, at the same time slap the upper foot with both palms, look at foot as you slap it;

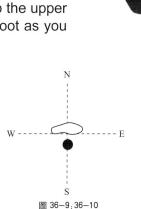

36-9

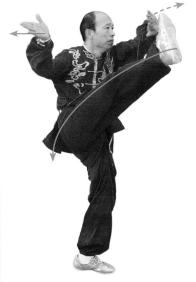

36-10

36. Fallen lotus (Swing kick drop split)

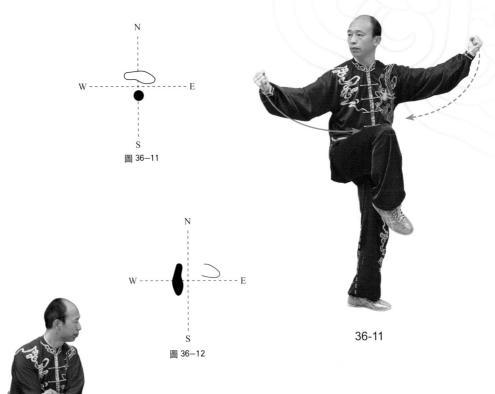

- 6 震腳合臂 右腳下震于左腳内側,同時兩掌 劃弧分開變拳再兩臂相合,右臂在下,目視 左前方向(圖 36-11,36-12),
 - f. Thud foot close arms drop right foot with a thud to the inside of left foot, at the same time palms arc apart and become fists then come together, left arm above, look to the front and left;

36. Fallen lotus (Swing kick drop split)

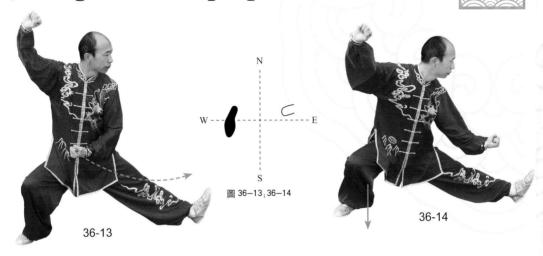

7 跌叉穿拳 左腳向左鏟出,左腿貼地,同時右腿屈膝, 内側貼地,左拳向左腿方向穿出,右臂内旋架于頭頂, 目視左拳方向(圖 36-13,36-14,36-15)。

g. Drop split cross fists – flatten left leg out to the left, on the ground, at the same time bend right knee, inside edge on the ground, pass left fist out over left leg, rotate right arm inwards to cover crown of head, look in direction of left palm.

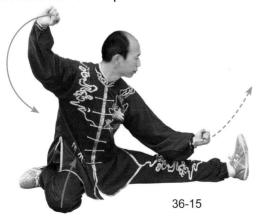

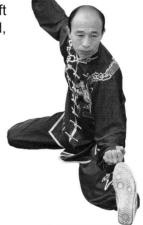

36-15 正面展示

(三十七)左右金鷄獨立

37. Golden Rooster Stands on one Leg (Left and Right)

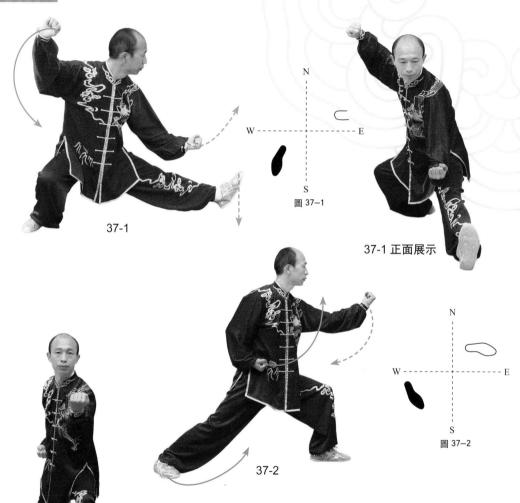

37-2 正面展示

1 弓步穿拳 左腿前弓,右腿后蹬,變弓步,左拳前穿,右臂内旋收至右腰側(圖 37-1,37-2),

a. Bow stance cross fists – arch left leg forwards, thrust right leg backwards, adopt bow stance, pass left fist forwards, rotate right arm inwards and draw to right waist;

(三十七)左右金鷄獨立

37. Golden Rooster Stands on one Leg (Left and Right)

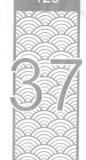

2 提膝穿掌 右拳經腰側變掌向上穿掌至頭頂,掌心向右,左臂内旋變掌,下按至左胯旁,同時提右膝,腳尖下垂,目視前方(圖 37-3,37-4);

b. Lift knee cross palms – right fist becomes palm beside waist and passes up to crown of head, palm facing right, rotate left fist inwards and make palm, press downwards beside left hip, at the same time lift right knee, toes hanging down, look ahead;

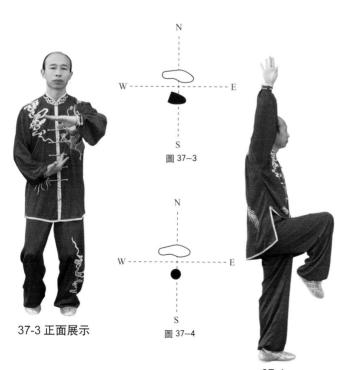

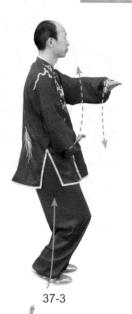

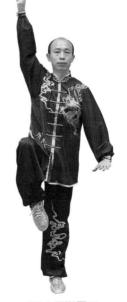

37-4 正面展示

(三十七)左右金鷄獨立

37. Golden Rooster Stands on one Leg (Left and Right)

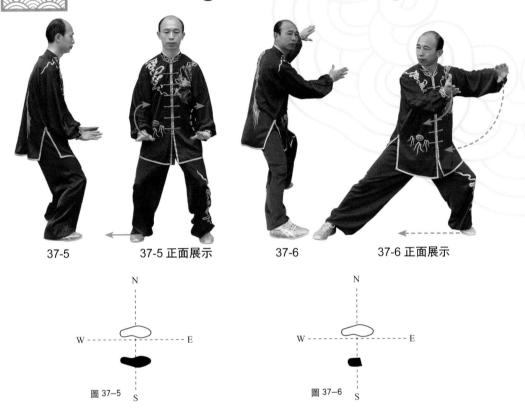

- **3 震腳下按** 右腳下震于左腳内側,重心在左腳,與肩同寬,同時右掌下按,兩掌在兩胯旁,目視前方(圖 37-5);
 - c. Thud foot press down drop right foot with a thud to inside of left foot, weight on left foot, shoulder width apart, at the same time press right palm downwards, palms beside hips, look ahead;
- **4 擦腳旋掌** 右腳向右擦出,同時兩掌逆時針旋轉至左側,掌心向外,目 視右腳方向(圖 37-6);
 - d. Slide foot rotate palms slide right foot out to right, at the same time whirl palms counterclockwise to the left, palms facing outwards, look in direction of the right foot;

(三十七) 左右金鷄獨立

37. Golden Rooster Stands on one Leg (Left and Right)

37 - 737-7 正面展示

- 5 收腳旋掌 重心右移, 收左腳至右腳內 側, 腳尖點地, 同時右掌内旋, 掌心向 下, 左掌外旋, 掌心向上, 目視前方(圖 37-7).
 - e. Close feet rotate palms shift weight right, draw left foot to inside of right foot, rest on tips of toes, at the same time rotate right palm inwards, palm facing downwards, rotate left palms outwards, palm facing upwards, look ahead:

- 6 提膝穿掌 左掌内旋上穿至頭頂,掌心向 左,右掌内旋下按至右胯旁,同時提左膝, 腳尖下垂、目視前方(圖 37-8)。
 - f. Lift knee cross palms rotate left palm inwards and pass up to crown of head, palm facing left, rotate right palm inwards and press down beside left hip, at the same time lift left knee, toes hanging down, look ahead.

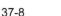

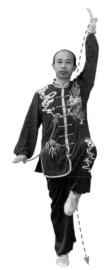

37-8 正面展示

38. Turn over arms (repulse monkey)

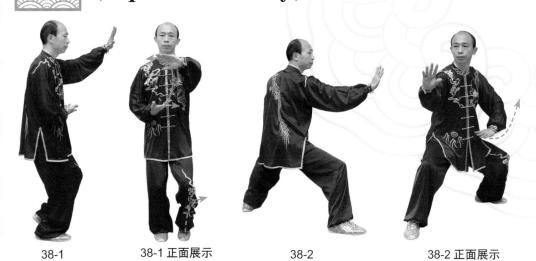

- **1** 屈膝穿掌 右腿屈膝,右掌外旋上穿,左掌外旋向下 與右掌相合,目視前方(圖 38-1);
 - a. Bend knee cross palms bend right knee, rotate right palm outwards and pass upwards, rotate left palm outwards and bring downwards to come together with right palm, look ahead;
- 2 撤步分掌 身體左轉,重心左移,左腳向左后方撤步,腳尖着地,右臂外旋向右前方推出,力達掌根,左掌内旋向左后方與右掌形成對拉至左膝上方,成左偏馬步,目視右掌方向(圖 38-2);

b.Withdraw and part palms – turn body left, shift weight left, withdraw left foot to the left and rear, landing on the toes, rotate right arm outwards and push out to the front and right, express force through base of palm, rotate left palm inwards to the back and left over the left knee, the two hands forming an opposing pair, adopt a left-biased horse stance, look in direction of right palm;

38. Turn over arms (repulse monkey)

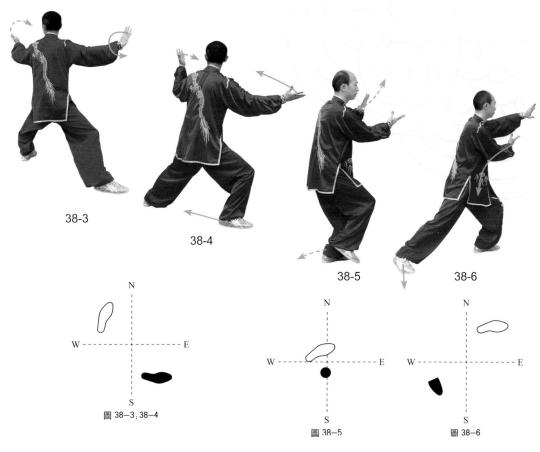

- 3 旋掌撤步 身體右轉,重心右移,右掌外旋,左掌外旋再内旋,兩掌相合,同時右腳向右后方撤步,腳尖着地,目視兩掌方向(圖 38-3;38-4;38-5;38-6);
 - c. Rotate palms and withdraw turn body right, shift weight right, rotate right palm outwards, rotate left palm outwards then back inwards, both palms come together, at the same time withdraw right foot to the right and rear, landing on the toes, look in direction of the palms;

38. Turn over arms (repulse monkey)

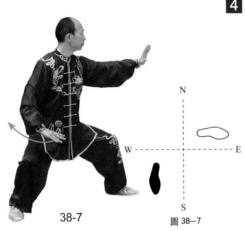

4 馬步分掌 身體繼續右轉,重心右移,左臂外旋向左前方推出,力達掌根,右掌内旋向右后方與左掌形成對拉至右膝上方,成右偏馬步,目視左掌方向(圖 38-7),

d. Horse stance part palms – continue turning body right, shift weight right, rotate left arm outwards and push out to front and left, express force through base of palm, rotate right palm inwards to the back and right over the right knee, the two hands forming an opposing pair, adopt a right-biased horse stance, look in direction of left palm;

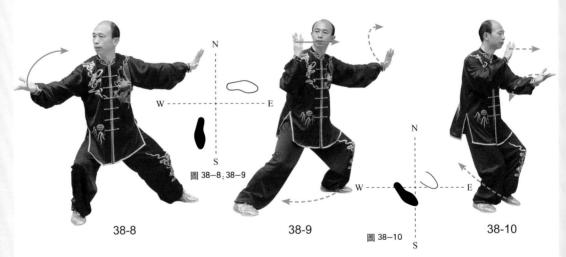

- **5** 旋掌撤步 身體左轉,左掌外旋,右掌外旋再内旋,兩掌相合,同時左腳向左后方撤步,腳尖着地,目視兩掌方向(圖 38-8;38-9;38-10;38-11);
 - e. Rotate palms and withdraw turn body left, rotate left palm outwards, rotate right palm outwards then back inwards, both palms come together, at the same time withdraw left foot to the left and rear, landing on the toes, look in direction of the palms;

38. Turn over arms (repulse monkey)

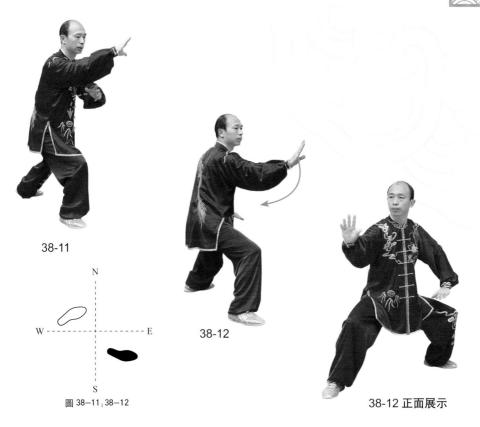

- 6 馬步分掌 身體繼續左轉,重心左移,右臂外向右前方推出,力達 掌根,左掌内旋向左后方與右掌形成對拉至左膝上方,成左偏馬步, 目視右掌方向(圖 38-12)。
 - f. Horse stance part palms continue turning body left, shift weight left, rotate right arm outwards and push out to front and right, express force through base of palm, rotate left palm inwards to the back and left over the left knee, the two hands forming an opposing pair, adopt a left-biased horse stance, look in direction of right palm.

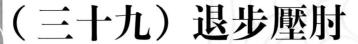

39. Step back and press from elbow

- **1** 左轉旋掌 身體左轉,右掌外旋向左平帶,左掌隨身體左轉左移,目視右掌方向(圖 39-1);
 - a. Turn left rotate palm turn body left, rotate right palm outwards and draw level to the left, turn body and shift weight left the left palm following, look in direction of right palm;
- **2** 右轉旋掌 身體右轉, 重心右移, 左掌外旋向右平帶, 右掌内旋向右平捋, 目視左掌方向(圖 39-2);
 - b. Turn right rotate palm turn body right, shift weight right, rotate left palm outwards and draw level to the right, rotate right palm inwards and draw level to the right, look in direction of left palm;

(三十九)退步壓肘

39. Step back and press from elbow

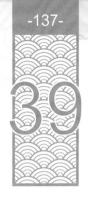

- **3** 翻臂收腳 身體左轉,重心左移,右臂外旋,掌心向上,左掌内旋收至右腋下,同時右腳走内弧收至左腳内側,目視右掌方向(圖39-3,39-4),
 - c. Flip arms close feet turn body left, shift weight left, rotate right arm outwards, palm facing upwards, rotate left palm inwards and bring under right armpit, at the same time bring right foot in an inward arc to inside of left foot, look in direction of right palm;

(三十九) 退步壓肘

39. Step back and press from elbow

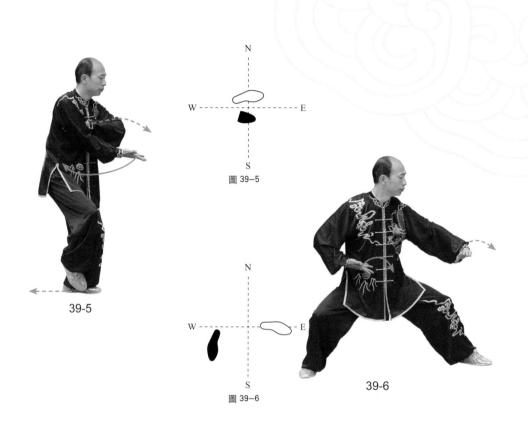

- 4 退步横擊 身體右轉,重心右移,右腳走内弧向右后方撤步,同時左掌經右腋下向前横擊,右肘向后發力頂肘,目視左掌方向(圖 39-5;39-6)。
 - d. Step back horizontal strike shift weight right, turn body right, step right foot back and to the right in an inward arc, at the same time with left palm make a horizontal strike from below the right armpit down and to the front, bring right elbow back expressing force through tip of elbow, look in direction of left palm.

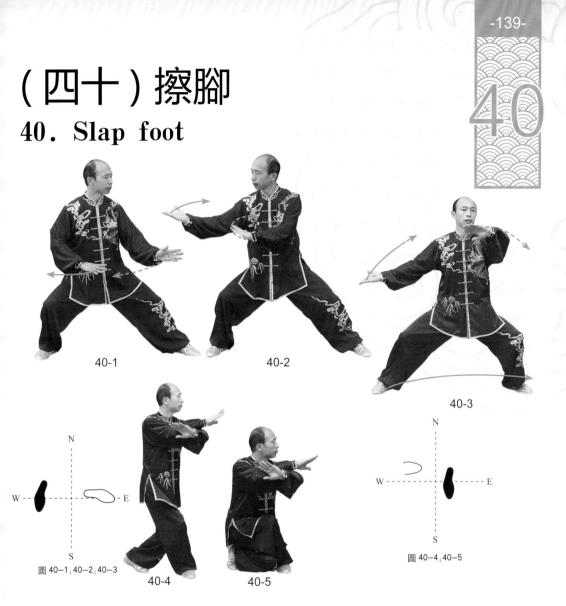

- **1** 翻掌右捋 身體右轉,右掌内旋,左掌外旋,同時向右捋帶,目視兩掌方向 (圖 40-1,40-2);
 - a. Flip palms pull right turn body right, rotate right palm inwards, rotate left palm outwards, at the same time pull to the right, look in direction of the palms;
- **② 歇步合臂** 身體左轉,重心左移,右腳向左蓋步成歇步,同時兩臂逆時針向左劃弧相合,右臂在上,目視兩臂方向(圖 40-3,40-4,40-5);
 - b. Rest stance close arms turn body left, shift weight left, right foot cross-step to left and adopt resting stance, at the same time both arms arc counterclockwise to the left and come together, right arm above, look in direction of the arms;

(四十)擦腳

40. Slap foot

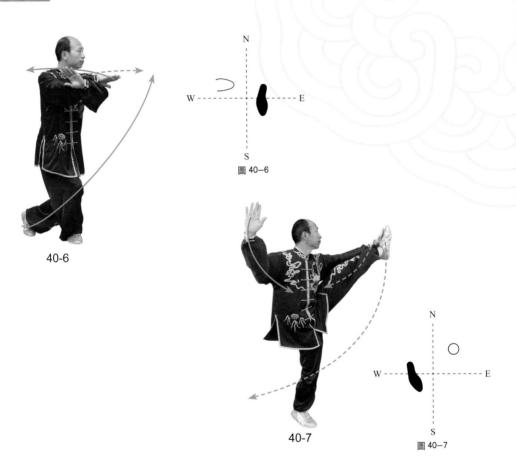

- **3** 分掌拍腳 左腳向左上踢,腳面綳平,同時兩手分開,左掌用力擊拍左腳腳面,目視左掌方向(圖 40-6,40-7)。
 - c. Part palms slap foot kick left foot up and left, keeping face (top) of foot flat, at the same time separate the hands, slap left palm hard on face of left foot, look in direction of left palm.

(四十一)蹬一跟

41. Heel kick

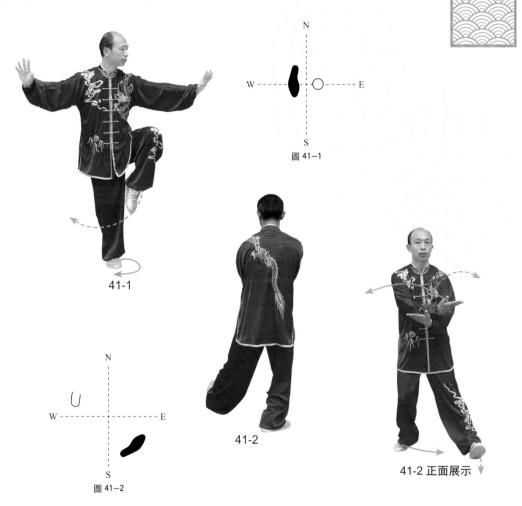

- 1 轉身合臂 身體右轉(180°),右腳以腳掌爲軸,左腳向右下擺,落在左前方,腳跟着地,同時兩臂向下劃弧相合,左臂在外,掌心向内,目視兩掌方向(圖41-1,42-2);
 - a. Turn around close arms turn body around (180°), with ball of right foot as axis, swing left foot down and right, drop to front and left, at the same time both arms arc downwards and come together, left arm outside, palms facing inwards, look in direction of the palms;

(四十一)蹬一跟

41. Heel kick

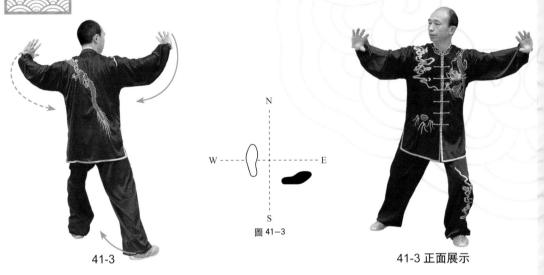

- **2 翻掌合臂** 重心左移, 收右腳至左腳内側, 兩臂向上向外劃弧分開再相合, 同時兩掌變拳, 右臂在外, 目視右方(圖 41-3,41-4),
 - b. Flip palms close arms shift weight left, draw right foot to inside of left foot,draw arms in an arc upwards and outwards then bring back together, at the same time the palms become fists, right fist outside, look to the right;

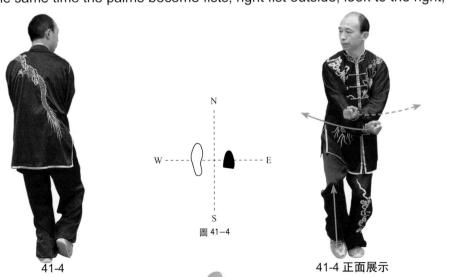

(四十一)蹬一跟

41. Heel kick

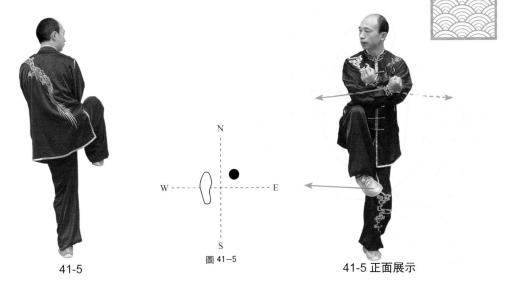

- 3 踹腳分擊 提右腳向右以腳外沿側踹,同時兩臂向兩邊以拳背爲力點分擊, 目視右拳方向(圖 41-5,41-6)。
 - c. Kick foot break apart lift right foot and kick out to the right with outer edge of foot, at the same time the arms strike out to each side with the point of force in the backs of the fists, look in direction of right fist.

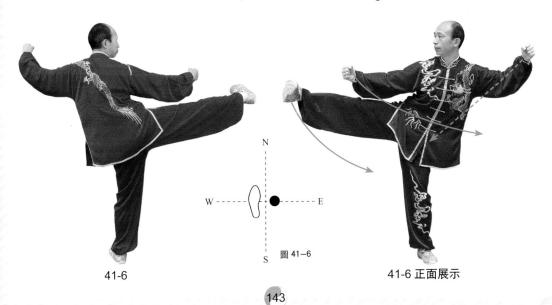

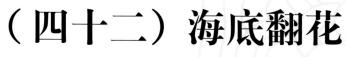

42. Turn out flowers from seabed

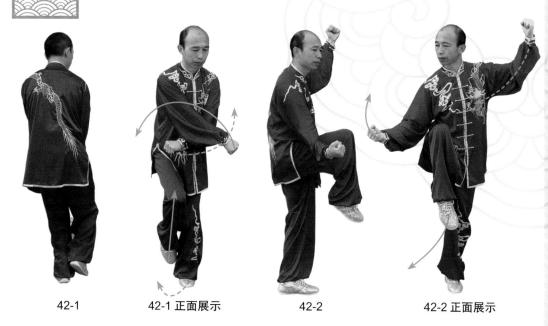

- 1 收腳合臂 身體左轉,兩臂相合, 右臂在外,右腳收回至左腳内側, 目視兩臂方向(圖 42-1);
 - a. Close feet arms together turn body left, bring arms together, right arm outside, bring right foot to inside of left foot, look in direction of the arms:

- **2 提膝翻臂** 身體右轉,左腳内扣,右膝提起,高過水平,腳尖下垂,右臂順時針翻轉,砸于右膝右側,左臂外旋,向右向上發力,左拳高與耳平,目視右拳方向(圖 42-2)。
 - b. Lift knee flip arms turn body right, turn left foot inwards, lift right knee, higher than level, toes hanging down, flip right arm clockwise, pound to right of right knee, rotate left arm outwards, expressing force up and to the right, left fist to ear level, look in direction of right fist.

(四十三)擊地捶

43. Punch to ground

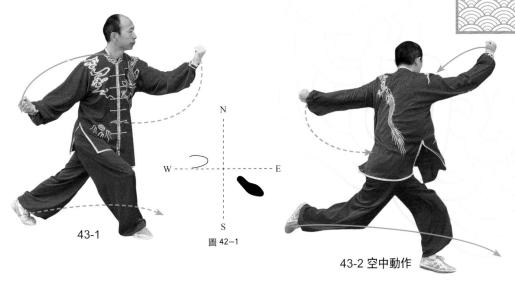

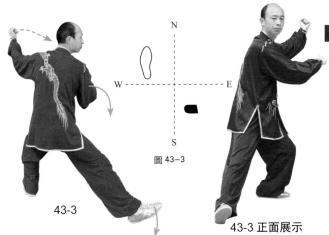

- ■落腳右轉 右腳向前落地, 腳尖外擺,同時身體右轉, 兩臂隨腰轉右擺,目視前方 (圖 43-1);
 - a. Drop foot turn right land right foot to front, swing toes outwards, at the same time turn body right, arms swing right following waist, look ahead;
- **2** 跳步掄臂 右腳蹬地向前跳兩步,右腳在前,右臂逆時針,左臂順時針掄轉,目視前方(圖 43-2,43-3),

b. Jump steps swing arms – thrust with right foot and jump forward two steps, right foot in front, swing arms around, right arm counterclockwise, left arm clockwise, look ahead;

(四十三)擊地捶

43. Punch to ground

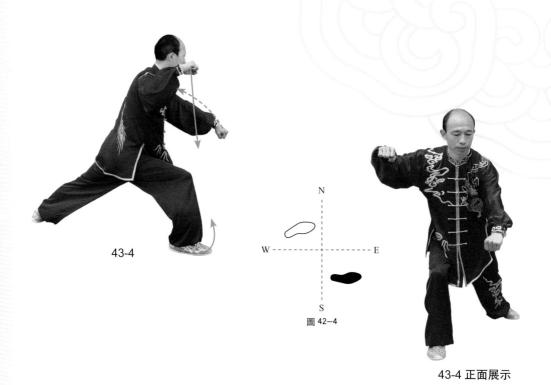

- **3 弓步栽拳** 身體右轉,左腳蹬地成右弓步,右臂經右膝前摟提至右肩前, 左拳經左耳側向前下方栽拳,目視左拳方向(圖 43-4)。
 - c. Bow stance fist punch turn body right, thrust left foot and adopt right bow stance, raise right arm past right knee to front of right shoulder, punch with left fist past left ear down and to front, look in direction of left fist.

44. Turn over and double kick

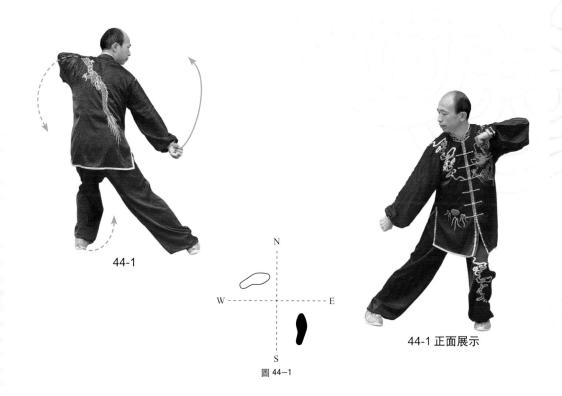

- **1** 后坐頂肘 身體左轉,重心左移,右腳尖内扣,左手曲臂向后頂肘, 右拳螺旋向下與左臂形成對拉(圖 44-1);
 - a. Sit back jab elbow turn body left, shift weight left, turn right foot inwards, with left arm bent jab elbow backwards, right arm spirals down, the two arms forming an opposing pair;

44. Turn over and double kick

- **2** 翻身舉拳 身體繼續左轉,左腳收至左前方,腳尖點地成虚步,兩臂隨身體左轉翻轉,目視前方(圖 44-2,44-3,44-4);
 - b. Turn over raise fist continue turning left, bring left foot to front and left, rest on tips of toes and adopt empty stance, arms flip and follow as body turns left, look ahead;

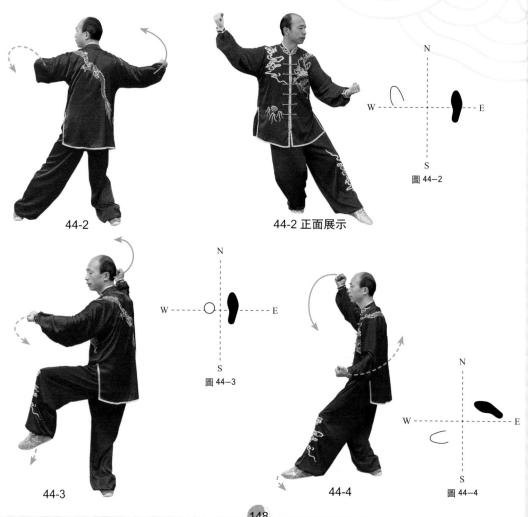

44. Turn over and double kick

- **3** 上步掄臂 左腳踏實,右腳上步,重心前移,身體左轉再右轉,兩臂隨轉 腰掄轉,目視前方(圖 44-5;44-6);
 - c. Step forward swing arms stand firm on left foot, step right foot forwards, shift weight forwards, turn body left then right, swing arms to follow waist, look ahead:

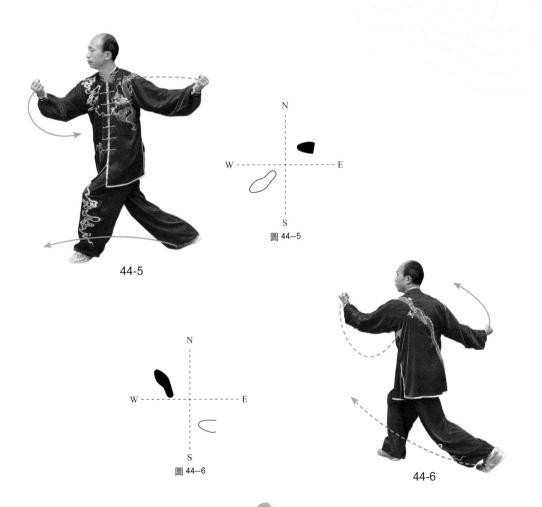

44. Turn over and double kick

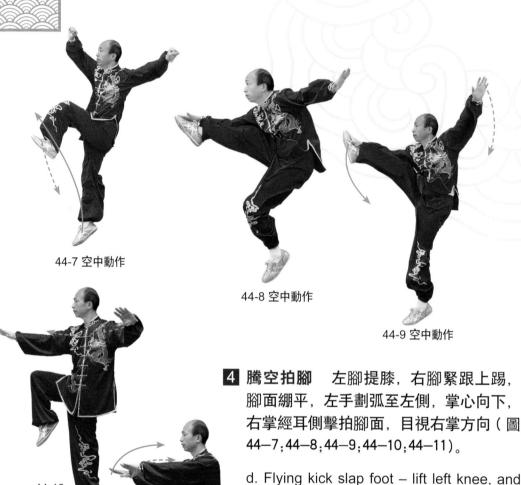

d. Flying kick slap foot – lift left knee, and simultaneously kick right foot up, keeping face (top) of foot flat, left hand arcs to the left, palm facing down, right palm passes ear to slap face of foot, look in direction of right palm.

44-11

圖 44-10:44-11

(四十五) 双震腳

45. Thud with both feet

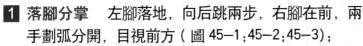

a. Drop foot part palms – land on left foot, jump backwards two steps, right foot in front, arms arc apart, look ahead;

45-3

2 上托下按 兩掌合勁外旋上托, 右掌在前,再内旋下按,目視兩 掌方向(圖 45-4,45-5),

45-1

 \bigcirc

圖 45-2

b. Lift up press down — both palms together rotate outwards and lift up, right palm in front, then rotate inwards and press down, look in direction of the palms:

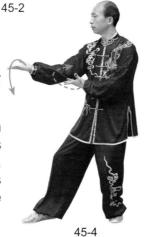

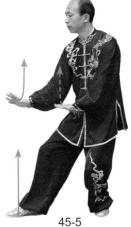

(四十五) 双震腳

45. Thud with both feet

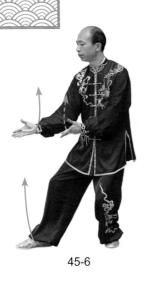

45-8

- 3 上跳托掌 兩掌外旋上托,同時兩腳上跳,右腳 先起,目視兩掌方向(圖 45-6;45-7);
 - c. Jump up lift palms palms rotate outwards and lift up, at the same time jump up with both feet, right foot first, look in direction of the palms.
- **4 震腳下按** 兩腳下震,左腳先落,重心在左腳, 同時兩掌内旋下按,目視兩掌方向(圖 45-8)。
 - d. Thud foot press down both feet land with a thud, left foot first, weight on left foot, at the same time rotate palms inwards and press down, look in direction of the palms.

(四十六)蹬腳

46. Heel Kick

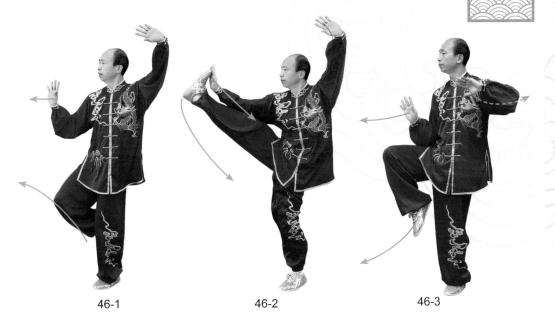

a. Lift knee draw palms – draw palms to front of chest, at the same time lift right knee, look ahead:

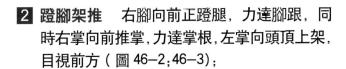

b. Kick out cover push – kick right leg straight out ahead, expressing force through the heel, at the same time push right palm ahead, expressing force through base of palm, left palm covers crown of head, look ahead;

(四十七) 玉女穿梭

47. Jade Maiden Working Shuttles

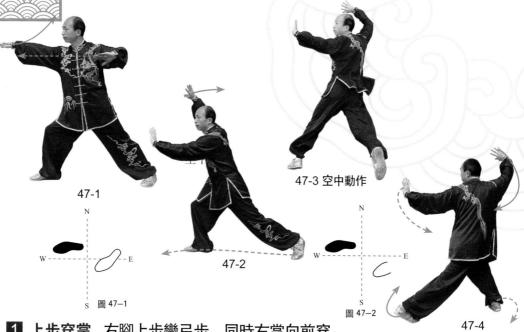

- 1 上步穿掌 右腳上步變弓步,同時右掌向前穿, 掌心向下,左手下落向左后方撑掌,目視右掌方 向(圖 47-1),
 - a. Step forward jab palm step right foot forward and adopt bow stance, at the same time jab right palm ahead, palm facing downwards, drop left hand and hold to left and rear, look in direction of right palm;

- **②**騰空架推 身體右轉,右腳蹬地,向前轉身跳兩步,右腳從左腳后側插出變 叉步,同時左掌向前推出,力達掌根,右掌向頭頂上架,目視左掌方向(圖 47-2,47-3,47-4)。
 - b. Flying jump cover push turn body right, thrust right foot, at the same time jump two steps and turn around: pass right foot behind left foot to form cross stance, at the same time push left palm out to front, expressing force through base of palm, right palm covers crown of head, look in direction of left palm.

(四十八)順鸞肘

48. Smooth Elbow Strike

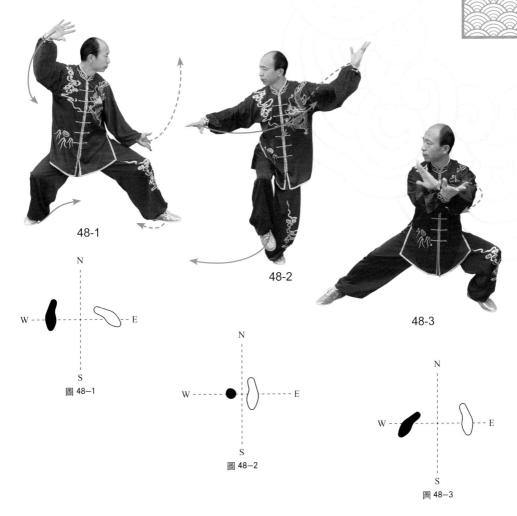

- **1** 擦腳合臂 身體右轉,右腳以腳前掌碾轉,左腳尖内扣,提右腳向右擦出,同時兩臂劃弧相合,右臂在外,目視右方(圖 48-1;48-2;48-3);
 - a. Slide foot close arms turn body right, roll right foot around on ball of foot, turn left toes inwards, lift right foot and slide out to the right, at the same time arms arc and come together, right arm outside, look to the right;

(四十八)順鸞肘

48. Smooth Elbow Strike

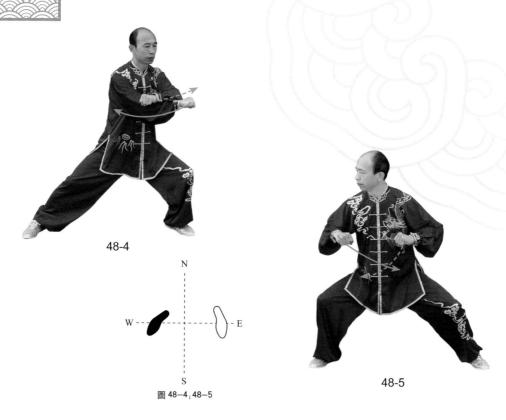

- **2** 馬步頂肘 身體微左轉再右轉,重心右移,兩掌變拳,兩臂曲肘,以 肘尖爲力點向后發力頂肘,成右偏馬步,目視右方(圖 48-4;48-5)。
 - b. Horse stance jab elbows turn body slightly left then right, shift weight right, palms become fists, elbows bent, jab elbows backwards forcefully with point of force in tip of elbows, adopt right-biased horse stance, look to the right.

(四十九) 裹鞭炮

49. Wrapping Firecrackers

1 左轉掄臂 身體左轉,重心左移,右臂順時 針向左向上劃弧,左臂向右向下,目視右拳 方向(圖 49-1;49-2);

a. Turn left swing arms – turn body left, shift weight left, draw right arm in an arc clockwise to the left and upwards, left arm to the left and downwards, look in direction of right palm;

2 提膝翻臂 提右腳身體右轉(180°),右臂逆時針劃弧,左臂順時針劃弧,目視右臂方向(圖49-3;49-4;49-5);

b. I ift knee flip arms – lift right foot turn body right (180°), arc right arm counterclockwise, arc left arm clockwise, look in direction of right arm;

(四十九) 裹鞭炮

49. Wrapping Firecrackers

(四十九) 裹鞭炮

49. Wrapping Firecrackers

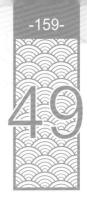

4 馬步分擊 身體微右轉再左轉,重心左移,兩臂向兩側劃弧分擊, 力點在兩前臂,成左偏馬步,目視左拳方向(圖 49-8)。

d. Horse stance break apart – turn body slightly right then left, shift weight left, arms break apart and arc to each side, point of force on each forearm, adopt left-biased horse stance, look in direction of left fist.

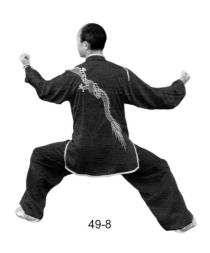

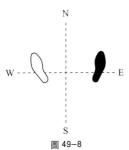

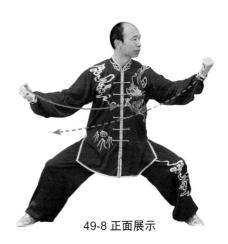

(五十) 雀地龍

50. Dragon Dives to Ground

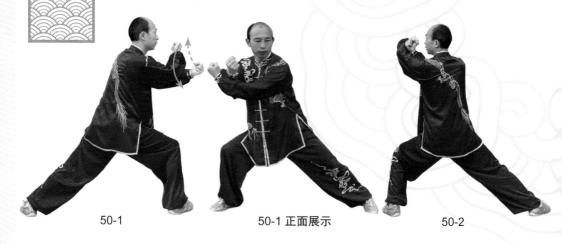

- **1 右轉合臂** 身體右轉,重心右移,左臂向右與右臂相合,左臂在下,目視兩臂方向(圖 50-1);
 - a. Turn right close arms turn body right, shift weight right, left arm come right to meet right arm, left arm below, look in direction of the arms;

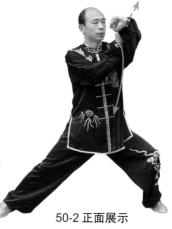

- **Z 左轉翻臂** 身體左轉, 重心左移, 兩臂劃弧向左翻轉, 左臂内旋, 拳心向外, 目視兩臂方向(圖 50-2);
 - b. Turn left flip arms turn body left, shift weight left, flip arms and arc to left, rotate left arm inwards, fist-heart (palm) facing outwards, look in direction of the arms:

(五十) 雀地龍

50. Dragon Dives to Ground

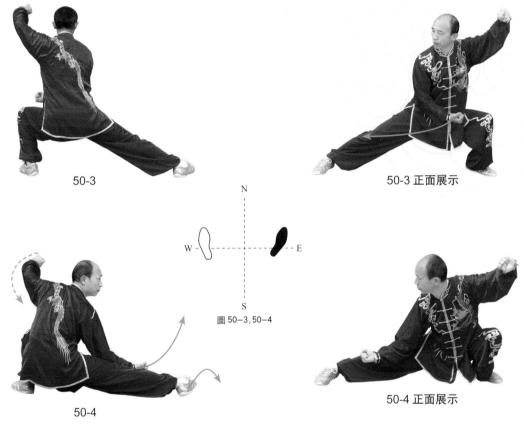

- **3** 僕步穿拳 身體右轉,左腳下蹲變僕步,右拳沿右腿向右前穿,高與腰平, 拳心向上,同時左臂向頭頂上架,目視右拳方向(圖 50-3,50-4)。
 - c. Drop stance cross fists turn body right, squat down on left foot to form drop stance, right fist passes to right and front along leg, at waist level, fist-heart facing upwards, at the same time left arm covers crown of head, look in direction of right fist.

(五十一) 上步七星

51. Step Forward Seven Stars

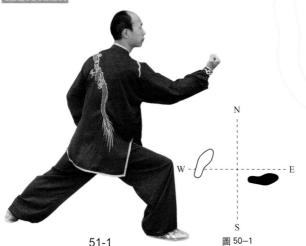

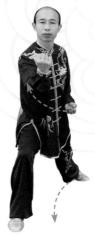

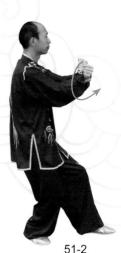

51-1 正面展示

- 11 弓步穿拳 身體右轉,重心右移,右腳尖外擺,左腳 尖内扣,成右弓步,右拳向前向上穿,高與肩平,左拳 劃弧收至左腰側,目視右拳方向(圖 51-1);
 - a. Bow stance punch fist turn body right, shift weight right, right foot swing toes outwards, left foot turn toes inwards, adopt right bow stance, punch right fist forwards and upwards, above shoulder level, draw left fist in an arc beside left waist, look in direction of right fist;
- **2 虚步架拳** 身體繼續右轉,重心右移,右腳尖外擺, 左腳上步,腳尖點地成虚步,同時左臂向前與右臂相合, 左臂在外,目視兩臂方向(圖51-2):
 - b. Empty stance cover fists continue turning right, shift weight right, right foot swing toes outwards, step left foot forwards, rest on tips of toes and adopt empty stance, at the same time bring left arm forward to meet right arm, left arm outside, look in direction of the arms;

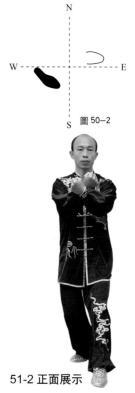

(五十一) 上步七星

51. Step Forward Seven Stars

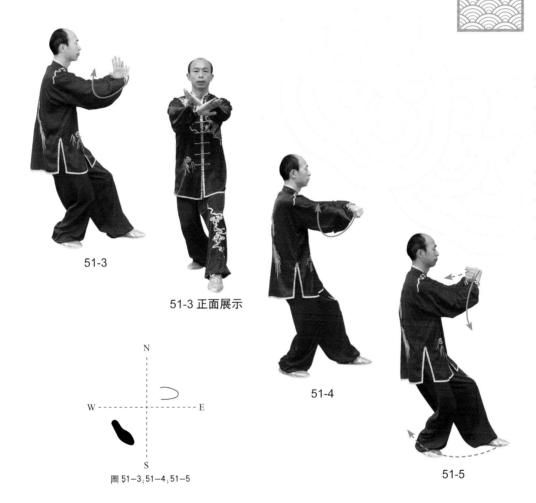

- **3** 變**拳翻**轉 兩臂向内翻轉,右臂向下向外翻,兩拳變掌,右臂在外,掌心向外, 兩掌變拳向内翻轉,右臂在外,目視兩臂方向(圖 51-3;51-4;51-5)。
 - c. Open fists flip over arms rotate inwards, flip right arm downwards and outwards, fists become palms, right arm outside, palm facing outwards, palms become fists and flip inwards, left arm outside, look in direction of the arms.

(五十二)退步跨虎

52. Step back straddle tiger

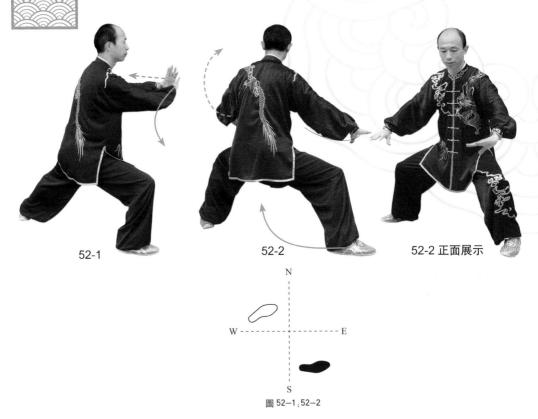

- **1** 變**掌撤步** 兩拳變掌,兩臂内旋,同時左腳向左后方撤步,目視兩掌方向(圖 52-1);
 - a. Open fists and withdraw fists become palms, arms rotate inwards, at the same time step left foot back to left and rear, look in direction of the palms;
- **2** 馬步分掌 身體左轉,重心左移,右腳内扣,左腳外擺,兩掌劃弧分開至兩膝上方,成左偏馬步,目視左掌方向(圖 52-2);
 - b. Horse stance part palms turn body left, shift weight left, swing left foot outwards, palms arc apart above each knee, adopt left biased horse stance, look in direction of left palm;

(五十二)退步跨虎

52. Step back straddle tiger

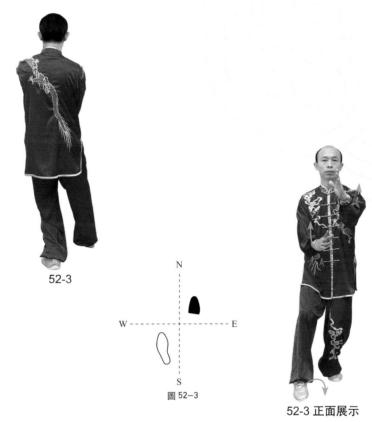

- **3** 丁步合臂 右腳收至左腳前側,腳尖點地變丁步,兩臂劃弧相合,左臂在上,掌心向右,右臂在下,掌心向左,目視兩掌方向(圖 52-3)。
 - c. Ding stance close arms bring right foot to forward of left foot, rest on tips of toes to form "Ding" stance, arms arc and come together, left palm above, palm facing right, right palm below, palm facing left, look in direction of the palms.

(五十三)轉身擺蓮

53. Turn Body, Swing (Lotus) Kick

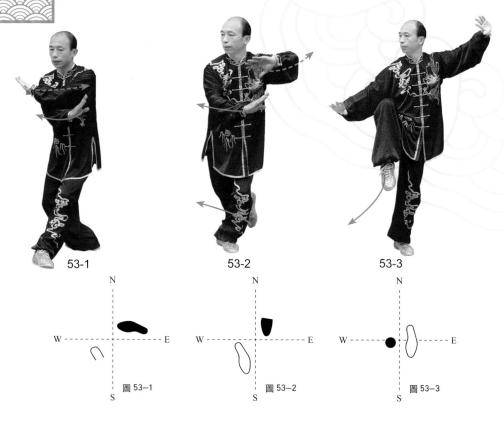

- **1 左轉合臂** 身體左轉,右腳以前腳掌爲軸碾轉,左腳尖外擺,同時兩臂相合,右臂在下,目視兩臂方向(圖 53-1;53-2);
 - a. Turn left close arms turn body left, roll right foot around on ball of foot, left foot swing toes outwards, at the same time arms come together, right arm below, look in direction of the arms:
- **2 提膝分掌** 提右膝,同時兩掌分開,左掌在左額前方,掌心向外,右掌在右膝右側,掌心向下,目視右掌方向(圖 53-3);
 - b. Lift knee part palms lift right knee, at the same time separate palms, left palm to upper left of forehead, palm facing outwards, right palm beside right knee, palm facing downwards, look in direction of right palm;

(五十三)轉身擺蓮

53. Turn Body, Swing (Lotus) Kick

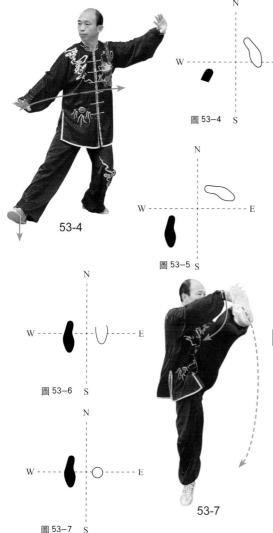

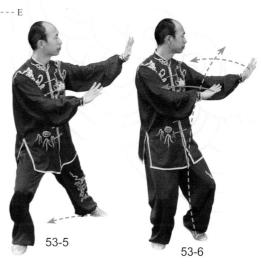

- 3 落腳擺掌 右腳向右前方擦出, 同時兩掌向左后方劃弧擺至左肩 前,目視兩掌方向(圖53-4;53-5);
 - c. Set foot swing arms slide right foot out to right and front, at the same time swing palms in an arc to left and rear in front of left shoulder, look in direction of the palms;
- 4 左外擺蓮 提左腳, 自右向左做扇形擺幅, 同時兩掌擊拍腳面, 目視拍腳 方向(圖 53-6,53-7)。
 - d. Left outside swing kick lift left foot, swing from right to left in the shape of a fan, at the same time slap the upper foot with both palms, look at foot as you slap it.

(五十四)當頭炮

54. Head-on cannons

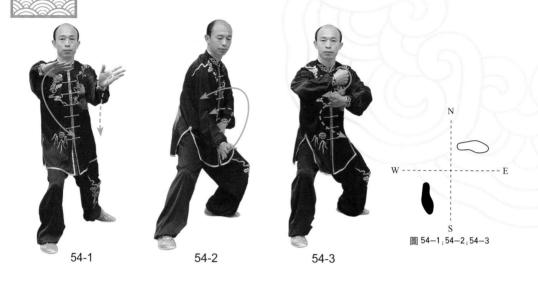

- **1** 撤步推掌 左腳向左后方撤步,同時兩掌向右前方平推,力達掌根,目 視兩掌方向(圖 54-1):
 - a. Step back push palms step left foot back to left and rear, at the same time push palms level to the right and front, expressing force through base of the palms, look in direction of the palms;
- **2** 左轉收拳 身體左轉,掌心左移,兩掌變拳向左向下回收至體前,目視前方(圖 54-2);
 - b. Turn left draw fists turn body left, shift weight left, palms become fists and draw left and downwards in front of body, look ahead;
- **3** 右轉掤擊 身體右轉,重心右移,同時兩臂向前掤擊,力點在兩前臂外側, 目視兩臂方向(圖 54-3)。
 - c. Turn right press strike turn body right, shift weight right, at the same time arms press and strike forwards, point of force on the outside of the forearms, look in direction of the arms.

(五十五) 左金剛搗碓

55. Guardian Pounds Mortar (Left Side)

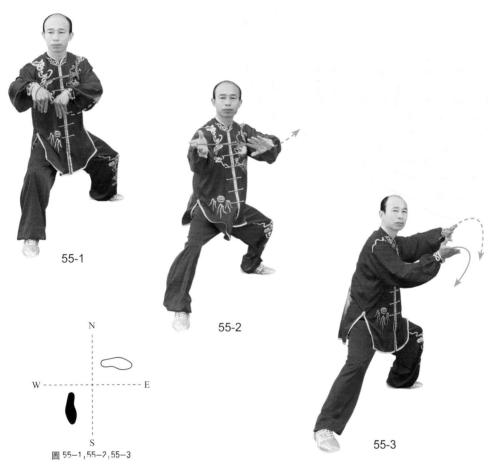

- **1** 變掌平捋 身體左轉,重心左移,同時兩拳變掌内旋,向左向后平捋,掌心向外,目視兩掌方向(圖55-1,55-2,55-3),
 - a. Open fists pull level turn body left, shift weight left, at the same time fists become palms rotating inwards, pull level to left and rear, palms facing outwards, look in direction of the palms;

(五十五) 左金剛搗碓

55. Guardian Pounds Mortar (Left Side)

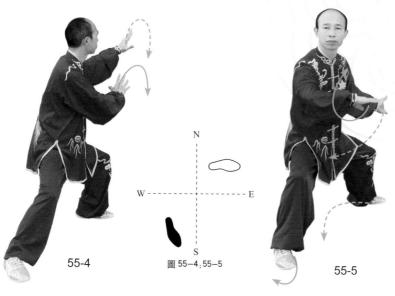

b. Swing palms relax hips – turn body right, shift weight right, relax hips swing palms, dip pelvis in a downward arc, look in direction of the palms;

c. Empty stance flick palm – step left foot forward bringing foot in an inward arc, rest on tips of toes and adopt empty stance, at the same time with right elbow bent flick right palm, flick left palm forward and bring right palm to meet it;

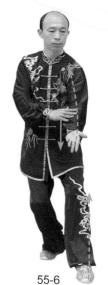

(五十五) 左金剛搗碓

55. Guardian Pounds Mortar (Left Side)

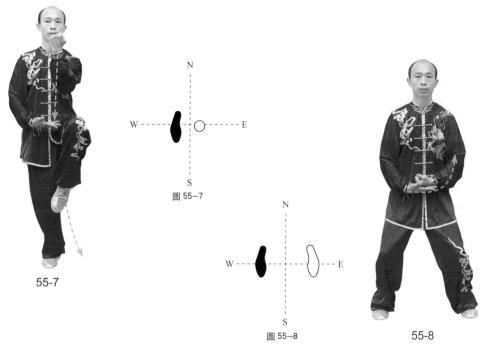

- 4 舉拳提膝 左掌變拳微下沉再上舉,與鼻同高,右掌收至腹前,掌心向上, 同時提左膝,高過水平,腳尖下垂,目視前方(圖 54-7);
 - d. Raise fist lift knee left palm becomes fist, dip slightly before raising to nose level, draw right palm in front of belly, palm upwards, at the same time lift left knee, higher than level, toes hanging down, look ahead;
- **5 震腳砸拳** 左腳下震,與肩同寬,重心偏右腳,兩腳平行,同時左拳以拳背砸于右掌上,目視前方(圖 54-8)。
 - e. Thud foot pound fist drop left foot with a thud, shoulder width apart, weight slightly right, feet parallel, at the same time pound back of left fist onto right palm, look ahead.

(五十六) 收式

56. Closing form

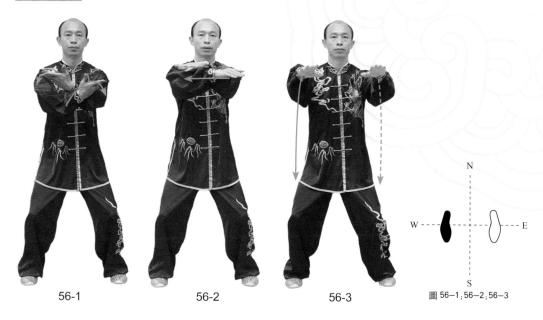

- **1** 上托變掌 左拳變掌,同時兩掌向上托,與肩同高,目視兩掌方向(圖 56-1)。
 - a. Open fist in palm left fist becomes palm, at the same time lift palms, to shoulder level, look in direction of the palms;
- **2** 翻掌平開 兩掌内旋翻掌,掌心向下,左右分開,與肩同寬, 目視前方(圖 56-2;56-3);
 - b. Flip palms level apart flip palms rotating inwards, palms facing downwards, left and right shoulder width apart, look ahead;

(五十六) 收式

56. Closing form

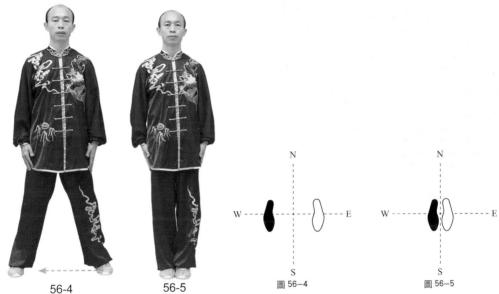

- **3 鬆肩下落** 鬆肩墜肘,兩臂下落至兩腿外側,目視前方(圖 56-4):
 - c. Relax shoulders drop down relax shoulders and allow elbows to fall, drop arms to outside of legs, look ahead;
- 4 並步還原 左腳收至右腳内側,並步還原,目視前方(圖 56-5)。
 - d.Return to equal stance bring left foot to inside of right foot, return to equal stance, look ahead.

【武術/表演/比賽/專業太極鞋】

正紅色【升級款】 XF001 正紅

打開淘寶天猫 掃碼進店

微信掃一掃 進入小程序購買

藍色【升級款】 XF001 橘紅

黄色【升級款】 XF001 黄

紫色【升級款】 XF001 紫

粉色【升級款】 XF001 粉

黑色【升級款】 XF001 黑

緑色【升級款】 XF001 緑

桔紅色【升級款】 XF001 桔紅

銀灰色【經典款】 XF8008-2 銀灰

藍色【經典款】 XF8008-2 藍

黄色【經典款】 XF8008-2 黄色

紫色【經典款】 XF8008-2 紫色

正紅色【經典款】 XF8008-2 正紅

黑色【經典款】 XF8008-2 黑

緑色【經典款】 XF8008-2 緑

桔紅色【經典款】 XF8008-2 桔紅

粉色【經典款】 XF8008-2 粉

【太極羊・專業太極鞋】

多種款式選擇・男女同款

打開淘寶天猫 掃碼進店

XF2008B(太極圖)白

XF2008B(太極圖)黑

XF2008-1 白

XF2008-2 白

XF2008-2 黑

XF2008-1 黑

XF2008-3 黑

XF2008B(無圖)

XF2008B(無圖)白

XF2008-3 白

XF2008B-1 黑

XF2008R-2 黑

XF2008B-1 白

XF2008B-2 白

5634 白

【太極羊・專業武術鞋】

兒童款・超纖皮

打開淘寶APP 掃碼進店

XF808-1 銀

XF808-1 白

XF808-1 紅

XF808-1 金

XF808-1 藍

XF808-1 黑

XF808-1 粉

微信掃一掃 進入小程序購買

【高端休閑太極鞋】

兩種顔色選擇・男女同款

軍緑色

深藍色

打開淘寶天猫APP 掃碼進店

微信掃一掃 進入小程序購買

【學生鞋】

多種款式選擇·男女同款 可定制logo

可定制logo

女款・學生鞋

檢測報告

商品注册證

男女同款・學生鞋

打開淘寶天猫APP 掃碼進店

微信掃一掃 進入小程序購買

20189

【專業太極服】

多種款式選擇・男女同款

微信掃一掃 進入小程序購買

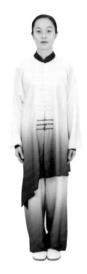

黑白漸變仿綢

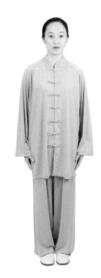

淺棕色牛奶絲

白色星光麻

亞麻淺粉中袖

白色星光麻

真絲綢藍白漸變

S 200 189

【武術服、太極服】

多種顔色選擇・男女同款

180

【專業太極刀劍】

晨練/武術/表演/太極劍

打開淘寶天猫 掃碼進店

手工純銅太極劍

神武合金太極劍

桃木太極劍

平板護手太極劍

手工銅錢太極劍

鏤空太極劍

手工純銅太極劍

神武合金太極劍

劍袋·多種顏色、尺寸選擇

銀色八卦圖伸縮劍

銀色花環圖伸縮劍

紅棕色八卦圖伸縮劍

微信掃一掃 進入小程序購買

【太極扇】

武術/廣場舞/表演扇 可訂制LOGO

紅色牡丹

粉色牡丹

黄色牡丹

紫色牡丹

黑色牡丹

藍色牡丹

緑色牡丹

黑色龍鳳

紅色武字

黑色武字

紅色龍鳳

金色龍鳳

純紅色

紅色冷字

紅色功夫扇

紅色太極

打開淘寶天猫APP 掃碼進店

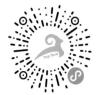

微信掃一掃 進入小程序購買

香港國際武術總會裁判員、教練員培訓班 常年舉辦培訓

香港國際武術總會培訓中心是經過香港政府注册、香港國際武術總會認證的培訓部門。爲傳承中華傳統文化、促進武術運動的開展,加强裁判員、教練員隊伍建設,提高武術裁判員、教練員綜合水平,以進一步規範科學訓練爲目的,選拔、培養更多的作風硬、業務精、技術好的裁判員、教練員團隊。特開展常年培訓,報名人數每達到一定數量,即舉辦培訓班。

報名條件: 熱愛武術運動, 思想作風正派, 敬業精神强, 有較高的職業道德, 男女不限。

培訓內容: 1.規則培訓; 2.裁判法; 3.技術培訓。考核內容: 1.理論、規則考試; 2.技術考核; 3.實際操作和實踐(安排實際比賽實習)。經考核合格者頒發結業證書。培訓考核優秀者,將會録入香港國際武術總會人才庫,有機會代表參加重大武術比賽,并提供宣傳、推廣平臺。

聯系方式

深圳: 13143449091(微信同號)

13352912626(微信同號)

香港: 0085298500233(微信同號)

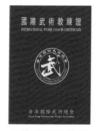

國際武術教練證

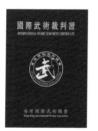

國際武術裁判證

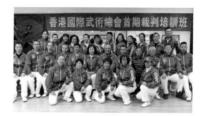

微信掃一掃 進入小程序

香港國際武術總會第三期裁判、教練培訓班

打開淘寶APP 掃碼進店

【正版教學光盤】

正版教學光盤 太極名師 冷先鋒 DVD包郵

打開淘寶天猫APP 掃碼進店

微信掃一掃 進入小程序購買

【出版各種書籍】

申請書號>設計排版>印刷出品
>市場推廣
港澳台各大書店銷售

冷先鋒

國際武術大講堂系列教學之一《陳式太極拳競賽套路 56 式》

香港先鋒國際集團 審定

太極羊集團 赞助

香港國際武術總會有限公司 出版

香港聯合書刊物流有限公司 發行

代理商: 台灣白象文化事業有限公司

書號: ISBN 978-988-74212-4-5

香港地址: 香港九龍彌敦道 525 -543 號寶寧大廈 C座 412 室

電話: 00852-95889723 \91267932

深圳地址:深圳市羅湖區紅嶺中路 2018 號建設集團大廈 B座 20A

電話: 0755-25950376\13352912626

台灣地址: 401 台中市東區和平街 228 巷 44 號

電話: 04-22208589

印次: 2020年7月第一次印刷

印數:5000冊 總編輯:冷先鋒 責任編輯:鄧敏佳 責任印制:冷修寧 版面設計:明栩成 圖片攝影:張念斯

網站: https://www.taijixf.com https://taijiyanghk.com

Email: lengxianfeng@yahoo.com.hk

本書如有缺頁、倒頁等品質問题, 請到所購圖書销售部門聯繫調換, 版權所有侵權必究